KB056354

오 계 숙

Lee, Ke-Sook

HEXAGON

한국현대미술선 029
오계숙

2015년 10월 12일 초판 1쇄 발행

지은이 오계숙
펴낸이 조기수
기 획 한국현대미술선 기획위원회
펴낸곳 출판회사 헥사곤 Hexagon Publishing Co.
등 록 제 396-251002010000007호 (등록일: 2010. 7. 13)
주 소 경기도 고양시 일산동구 숲속마을1로 55, 210-1001
전 화 070-7628-0888 / 010-3245-0008
이메일 coffee888@hanmail.net

ISBN 978-89-98145-52-1
ISBN 978-89-966429-7-8 (세트)

오 계 숙

Lee, Ke-Sook

HEXAGON
Korean Contemporary Art Book
한국현대미술선 029

029

● **Note**

집사람
House Woman

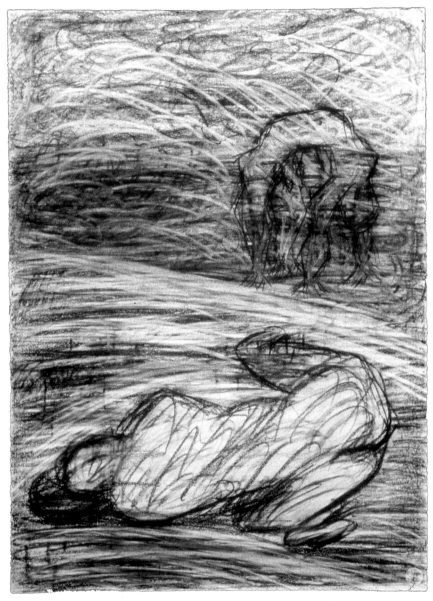

땅에 매달리다_ Hanging on to the ground, 1986, graphite, pencil, 96×81cm

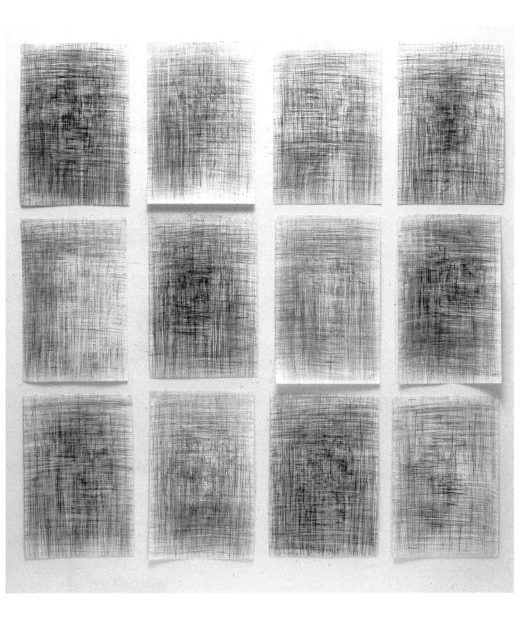

나는 누구인가_ Who am I (Study of my Face), 1998, graphite, pencil, 172×178cm

집사람

나의 작품은
여성의 경험과 환경에 적응하며 나타난
여인의 모습을 보여 준다.

여자로서 겪은 경험 중
가장 충격받은 기억은
내 세대의 여인들이 한국에서 처음으로
대학 교육을 받은 것이 특별했다.

우리는 직장에서 사회인으로
일하는 경험도 가졌으나 결혼한 후엔
집안에서 애 낳고 키우며 살림하는
집사람이 되었다.

아이들을 키운 후
나는 학교를 다시들어가 미국학위를 땄으나
또다시 내 부엌으로 돌아오게 되었다.

나의 꿈은 어디로 갔나 ?

나는 누구인가 ?

여자란 무엇인가 ?

천천히 작업실에서 붓은 사라지고
실과 바늘을 쥐고
옛 부인들이 썼던 천조각에
손자수로 여자를 그리게 되었다.

수놓아 그려진 변형된 여인 모습은
여자로서의 경험과 기억으로 탄생된
어머니, 가정부인, 집사람, 딸
또 다른 인간의 모습이다.

어릴 적 한국에서
할머니에게 손자수를 배웠다.

할머니는 문맹인이였고
그녀의 온 세계는 집안이었다.

그러나 할머니는 손자수로
그녀의 마음과 정열을 표현 하실줄 아셨다
마치 당신의 언어처럼.

내 작품은
옛 할머님들의 인내와 창작력에 감동한
결과물이다.

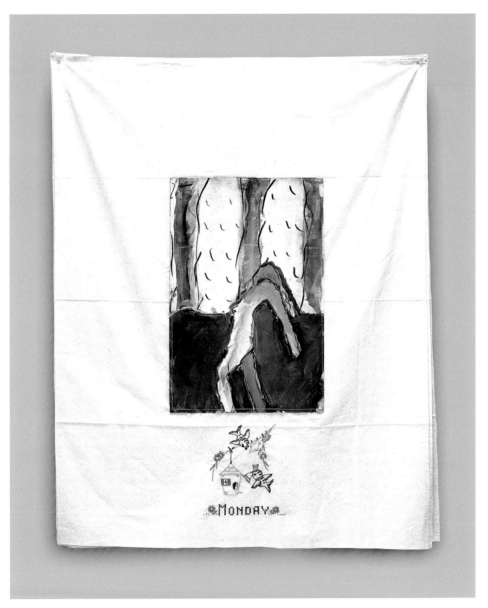

행주일기, 월요일 _Dish Towel Dairy, Monday,1999, vintage dish towel, mixed media, 53×53cm

House Woman

Reflecting on feminine experience
and condition, the image of woman was
born on the work.

One of the most unforgettable experience
I had is that I am the first generation of
woman who went to college and earned
the degree in Korea.

Some of us got a job out side of the home,
But after they got married, settled at home
giving birth and raise children,
and became a full time homemaker.

After raising children I went back to school
in US, earn my second degree
but landed in the same old kitchen.

Where does my dream go?

Who Am I?

What does the woman means?

Gradually brushes has disappeared in my
home studio, found myself holding
thread and needle making hand embroidered
image of woman on vintage household linen
that once used by women.

These embroidered transfigured
women are born from my memory
and experience of being a mother, wife,
daughter, homemaker and an individual.

I learned embroidery from my
grandmother as a little girl in Korea.
She was a house woman.
She did not know how to read and write
but knew how to express her impassioned
thoughts through embroidery
as if it is her language.

My work was inspired by
her gracious patience and creativity.

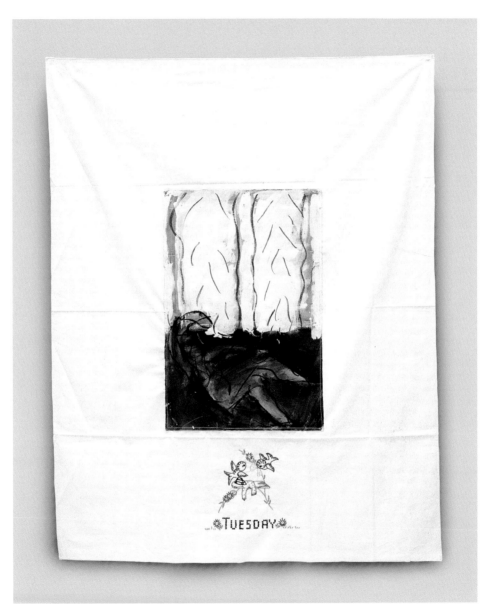

행주일기, 화요일 _Dish Towel Dairy, Tuesday,1999, vintage dish towel, mixed media, 53×53cm

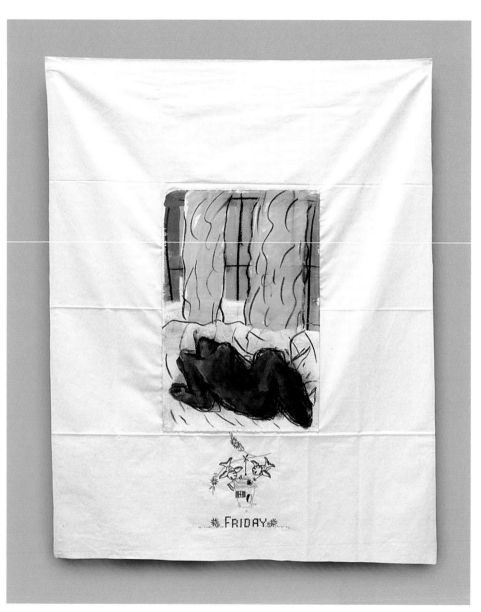

행주일기, 금요일 _Dish Towel Dairy, Friday,1999, vintage dish towel, mixed media, 53×53cm

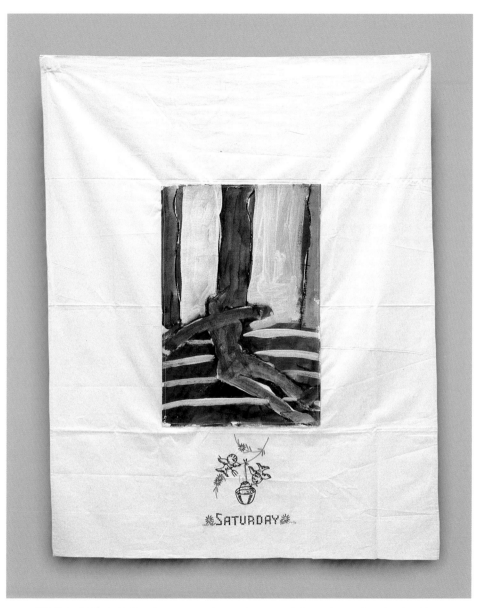

행주일기, 토요일 _Dish Towel Dairy, Saturday,1999, vintage dish towel, mixed media, 53×53cm

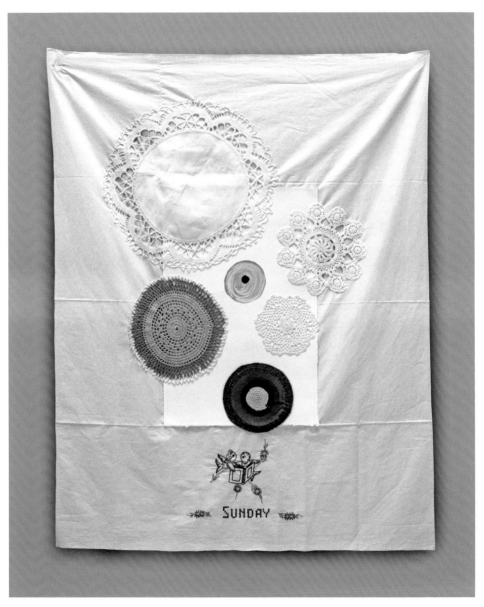

행주일기, 일요일 _Dish Towel Dairy, Sunday,1999, vintage dish towel, mixed media, 53×53cm

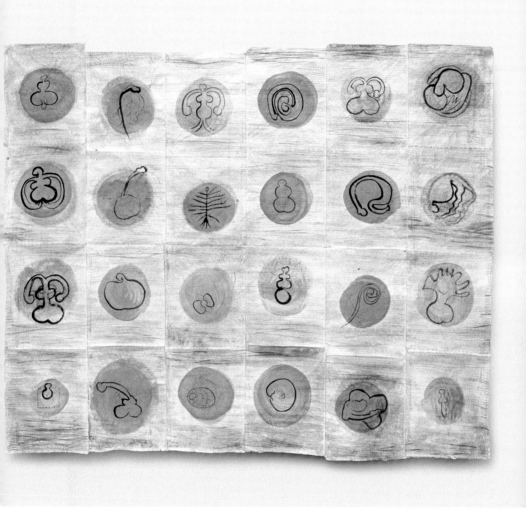

한해가 다가도록 기다리다_ I have been waiting all year long, calligraphy ink, earth, thread, Korean paper, 129×152cm

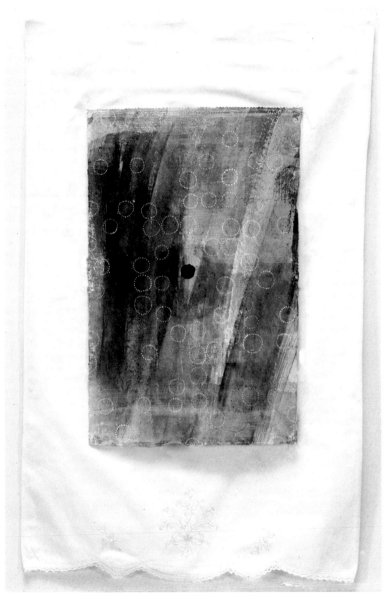

그녀의 지구는 따뜻하다_Her earth is warm, 2000, calligraphy ink, Korean paper, earth, vintage pillowcase, 81×53cm

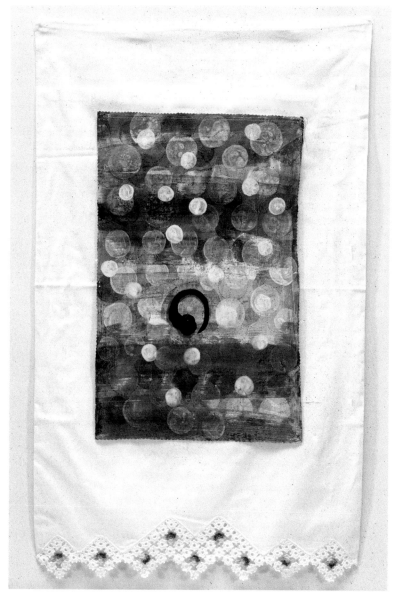

그녀의 뿌리는 따뜻하다_Her root is warm, 2000, calligraphy ink, Korean paper, earth, vintage pillowcase, 81×53cm

Ke-Sook Lee USA Apron 1 2002,

stitching on Tarlatan, aprox. 79"x71"

Positioned to the domestic, and hanging in the range of a certain minimalism, though unbound by objectness, or conceptual counter turns, Ke-sook Lee pushes the needle through an oversized apron and pulls it back out onto a world of micro diffusions and energies which when you stand back to look reach almost galactic proportion. At close range this out-sizeyness holds nothing other than stitches and holes in and through a super-thin cloth. You find doodles in haberdashery, fine stitches holding together ends of missing thread; patterns hobbling in and out of small rips or tears. Take the whole thing in again and the shadows formed from the denser bits, stitches, and folds, are thrown back into the wall, destabilizing the real, of what little there is. Scattered larger holes, ephemeral, and by no means hinting at the vortex, just sit in absence, burning outward, and look to be the only real thing that you can find retinal hold. What isn't there is then expressively clear.

Brent Hallard,

Tokyo Note 2003/04

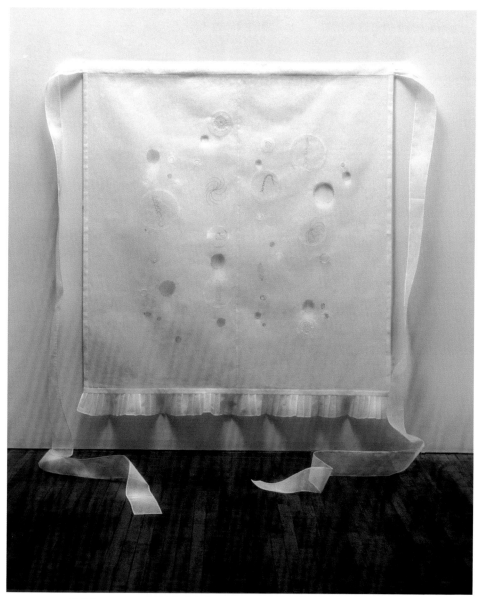

앞치마 _Apron 1, hand embroidered thread, tarlatan, vintage doily, 180×180cm
4th International contemporary Art, Florence Biennale, Italy

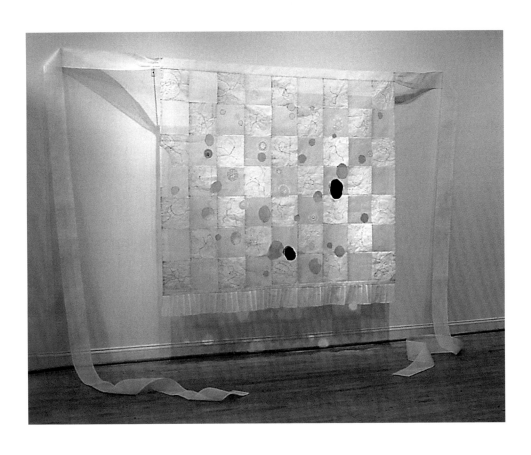

앞치마_Apron 3, hand embroidered thread, Korean paper, vintage doily, tarlatan, earth, 180×180cm
Snyderman Gallery, Philadephia, PA

KE-SOOK LEE - BETWEEN CULTURES AND GNERATIONS

NOT ONLY PERSERVING ANCIENT SKILLS, HER WORK SUGGERSTS THEIR METAMORPHOSIS INTO A UNIVERSAL LNAGUAGE OF ART

BY SIGRID WORTMANN WELTGE

Ke-Sook Lee is emerging as an important artist of our time. But how to take her measure? Her work is so multivalent, so personal and complex, it resists neat categorization. Variously referred to as mixed media, installation or fiber art, it has visceral presence that holds viewers in thrall. The art of Ke-Sook Lee mirrors her life. She draws inspiration from the duality of having roots in two countries, of practicing as a professional artist while relishing the role of mother, homemaker and gardener. Born in 1941 in Seoul Korea, she experienced not only family division but family loyalty and, above all, matriarchal strength. As a child she shared a room with her grandmother and great-grandmother, expert needlewomen who passed their skills on to their charge. A year after receiving a B.F.A. in applied art from Seoul National University in 1963, Lee and her husband immigrated to the United States. She pursued postgraduate studies at the University of Missouri and in 1982 received a second B.F.A., in painting, from the Kansas City Art Institute, where she later taught mixed media drawing.

While mother hood interrupted Lee's career, it also became the springboard for her future artistic direction. Abandoning drawing and oil painting for calligraphy on rice paper, she then took up stitching and embroidery. The domestic sphere - sewing, mending, ironing and tending to house and garden - is the underlying theme of each of her creations. Her preferred material is tarlatan, a sheer plain - woven cotton, heavily sized for stiffness. It serves as the foundation for her multilayered collages, but is itself manipulated to convey directional lines through

sharply ironed creases. Lee has as much affection for her collection of American domestic fabrics - worn pillowcases, tow els and doilies – as she does for Korean rice paper. She unites these seemingly dis- parate materials by stitching them onto tarlatan. Her vibrant needlework not only expresses the beauty of calligraphic line, but also provides a text extolling simple domesticity Earth from her garden provides pigments for the subtlest color gradations.

Lee's most recent work, "Stitches from the garden," an exhibition/ installation at Sny-derman Gallery, Philadelphia, this past June, consisted of various smaller pieces, but was dominated by oversized Aprons mounted against the wall and Arm Pillows suspend- ed from the ceiling. One imagined that a gigantic earth mother had just left the room. Lee celebrates and honors women's domestic duties by bestowing heroic status on objects that normally go unnoticed. At first glance 'Apron 3,' 2004, has a quilt like appearance, except for the pleated ruffle at the bottom and apron strings trailing to the floor. Despite the partially diaphanous material, its presence is overwhelming. Each square contains or is overlapped by amoebic shapes and circles of appliquéd rice paper and doilies. Embroidered into place, they are surrounded by exuberantly expressive stitched lines. One cannot help being reminded of Matisse's Joie de Vivre. Spirals, ancient symbols of spirituality, are another recurring theme. This affirmation of life is evident in the title of the Apron pieces 'Seed Pods' and 'Maternity.' Earth pigments impart deep, rich hues, resulting in a surface reminiscent of Italian mar- ble. Reflecting a modern, abstract aesthetic, the Aprons are simultaneously flat and dimensional………

The Arm Pillow pieces, like floating wind socks, are full of visual surprises. Looking at and through the layers of tarlatan, one sees changing yet interacting planes. Stitches hold the familiarly shaped appliqués in place, but they also surround and draw attention to cut outs, which form windows and voids, underlined by sharply ironed directional creases. ……

…… Although Lee' work is undeniably feminine in subject matter, its minimalist style has universal appeal. By means of singular artistic vision and nontraditional

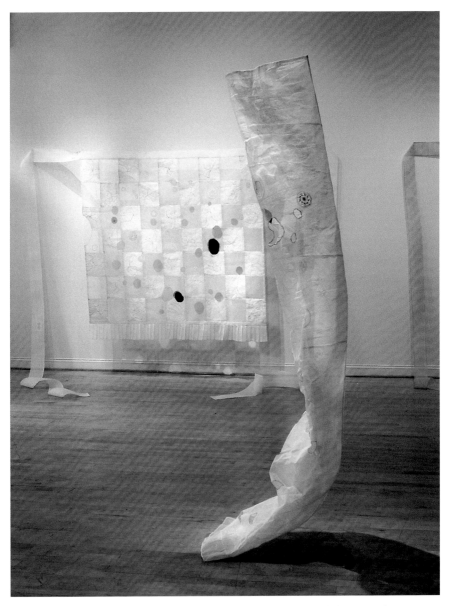

팔벼개_Arm Pillow #3, 2004, hand embroidered thread, tarlatan, vintage doily, 203× ø61cm

materials and techniques, she has achieved a transfiguration of images that might easily have slid into sentimentality. Her two variations of 'Seed Pods on Clothesline,' for instance, are starkly abstract, evocative pieces whose interpretations are entirely personal and open-ended.

she is, in her words 'exploring the boundaries of art making.' At the same time, she is a storyteller recalling a vanishing way of life. While motherhood has not changed, female domestic chores certainly have. The needle skills Lee so vividly conjures up are unknown to modern young women pursuing professional careers. Her work, therefore, not only preserves ancient skills but suggests their metamorphosis into a universal language of art.

Ke-Sook Lee's art resonates because it is at once ancient and modern. A woman of two countries, she stands between cultures and generations. She has listened to her ancestors, to women in their private sphere, to her garden and the exigencies of contemporary mark making. From the experience of her life she has created a multilayered yet unified body of work provoking the extraordinary power of art to transform the ordinary.

Sigrid Wortmann Weltge is professor emerita at Philadelphia University and the author of Bauhaus Textiles: Women Artists and the Weaving Workshop (Thames and Hudson, 1998)

Quote from American Craft, Vol.64, No.6, December 2004 /January 2005, p.32~ p.35.

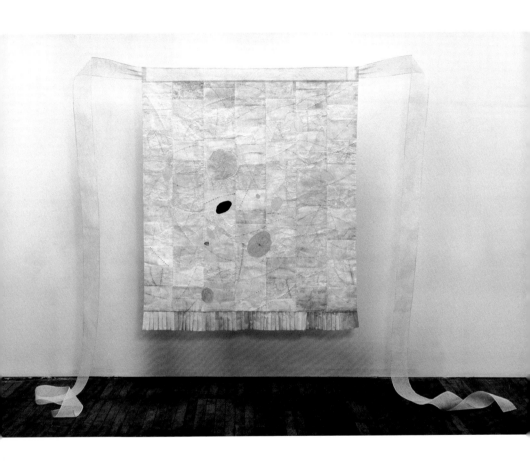

앞치마 _Apron 4, 2004, hand embroidered thread, Korean paper, earth, mixed media, 167×165cm
Collection of Racine Art Museum, WI

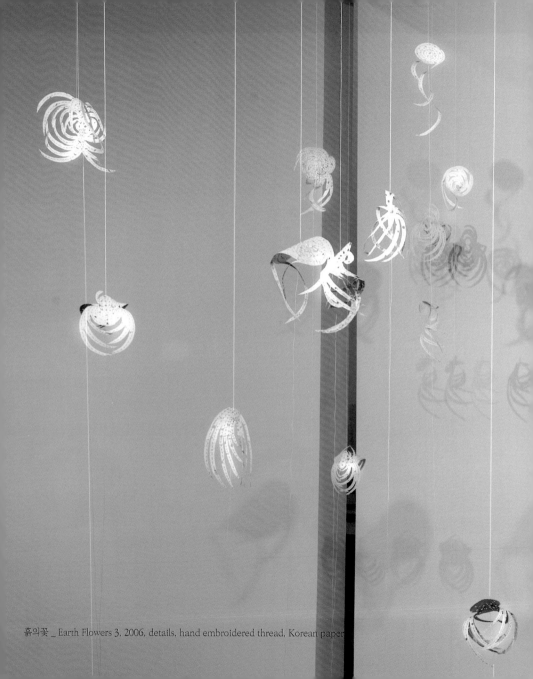

흙의꽃 _ Earth Flowers 3, 2006, details, hand embroidered thread, Korean paper

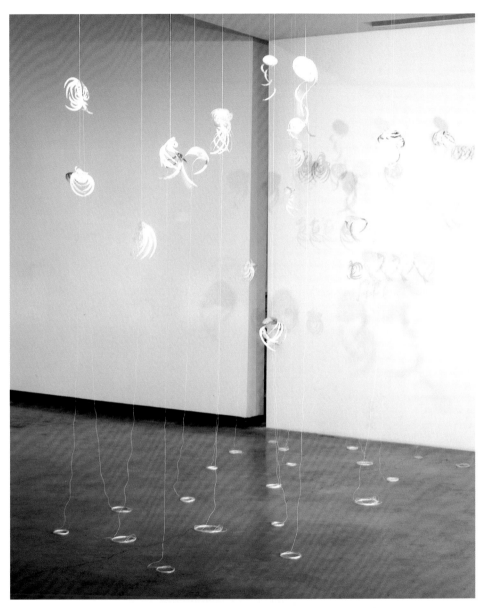

흙의꽃 _ Earth Flowers 3, 2006, hand embroidered thread, Korean paper, 36×23×30cm

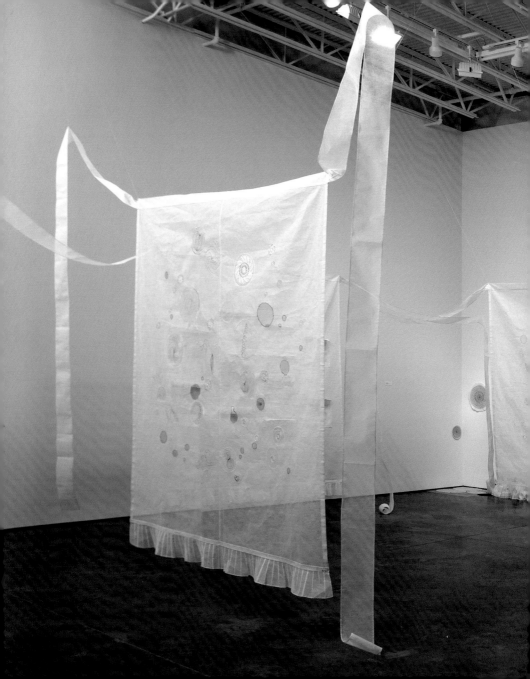

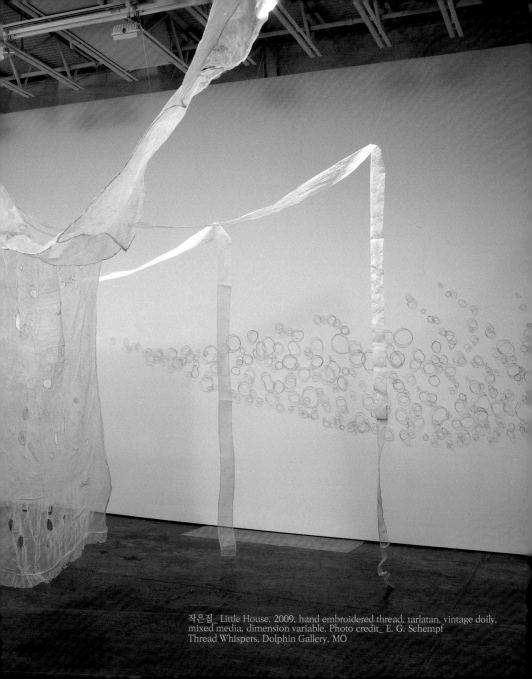

작은집_ Little House, 2009, hand embroidered thread, tarlatan, vintage doily, mixed media, dimension variable, Photo credit_ E. G. Schempf
Thread Whispers, Dolphin Gallery, MO

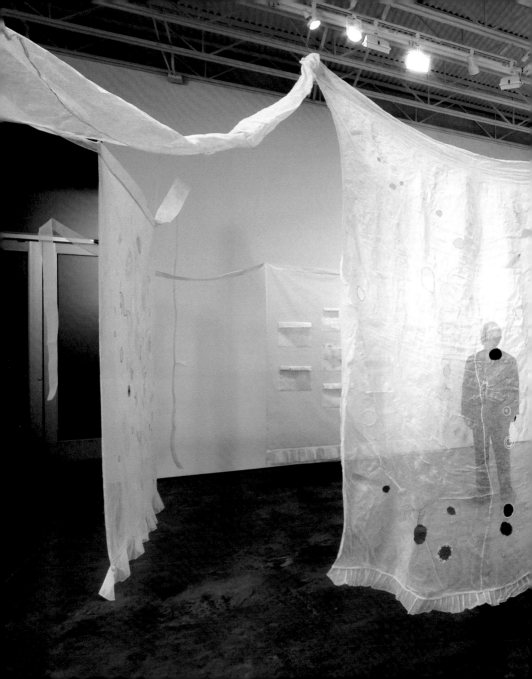

EASTERN INFLUENCES, GOOD VIBRATIONS

Installation artist Ke-Sook Lee creates a cloud-like fantasy of gauzy fabric, whose four "walls" surrounded you. Contrasting the cold concrete floor below, the Little House gives the effect of the viewer's existing in, rather than on, a cloud. One felt isolated, protected and comforted all at once in the filmy womb-like environment. Surrounding walls display varying ideas using vintage fabric dating to the Victorian era that have a whimsical feeling of aprons. The burns and ruffles meandering throughout these fabrics are befitting a sensuous domestic goddess — a Venus whose work is never done; these are the scars she bears.

Lee's use of thread as a mark-making device is representational of her life experience. Seeing what exists in the world of mother, wife, homemaker and artist, Lee explores ideas and textures with a capable and nurturing hand. The surface relays an embodiment that takes the artist beyond her own experiences of life in both the United States and her native Korea. A gallery corner holds an installation of wire and linen "bubbles" floating upwards, projecting a fairly lightheaded feeling, as if you were at the bottom of a champagne glass.

By Blair Schulman, art writer and critic
Quote from Review-magazine, 6.26. 2009

작은집_ Little House, 2009, hand embroidered thread, tarlatan, vintage doily, mixed media, dimension variable

작은집_Little House, 2009, hand embroidered thread, tarlatan, vintage doily, mixed media, dimension variable

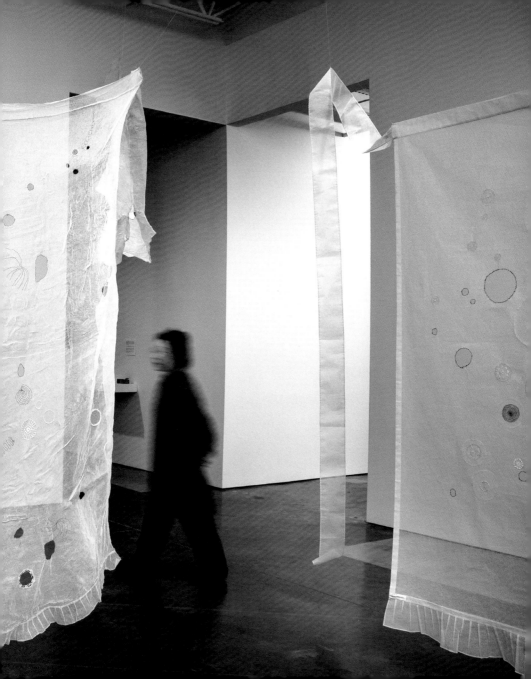

'Ke-Sook Lee's Thread Whisper_Following Narrative Thread

In her current installation "Thread Whisper", Ke Sook Lee incorporates many of her favorite leitmotifs: transparent aprons the size of doors; vintage crochet work, idiosyncratic embroidered "drawings" on various textiles; and pigment made from dirt and vegetables from her garden. It's possible your grandmother's hankie found its way into this show, now illustrated with Lee's hermetic, stitched narratives.

Over the past decade, Lee has exhibited variants of such textiles internationally. But "Thread Whisper" is the first time Lee has amassed, in one room, her complete asethetic arsenal representing a subject she continues to exhaustively investigate: the home and its female householders. For her, it is a topic both highly personal and of continuing global concern.

"Thread Whisper" is part reverie and part stage set. Lee's installation, which was mounted by her son John Sangjun Lee, literally hangs by threads and pins. It consists of a four-sided house dangling in the center of the room, and various stages of a garden installed around the periphery. One need not fully grasp Lee's narrative to appreciate the ghost-like, stitched and stained textiles that float throughout the room and on the walls. But if one looks at Lee's forms long enough, ancestral spirits seem to weave in and out of the various settings, whispering stories essentially inaudible. Lee's work aims to give them a voice.

She can do this because her own history resonates with the stories of generations of anonymous women whose lives were limited to the confines of their homes.

Lee is Korean. She was fourteen when, just after the Korean war, she was put in charge of the family home. "I grew up in a Confucianism background," Lee said in a recent interview. "Women had no social life then; they could only be at home working. They had to do all the cooking and make all the clothes. And homemakers had no social status. The most fun part," she recalls, "was doing embroidery. It was the most individual expression women had."

After Lee married, she moved to Kansas City with her husband, Dr. Kyo Rak Lee, who was a radiologist and taught at KU Medical Center. Once again Lee became a householder, this time in a foreign country, with two small children. After her sons were

older, she attended the Kansas City Art Institute where she received a BFA in 1982.

Lee has since worked in many media, but ten years ago she began focusing exclusively on textiles. She incorporated vintage, hand-crocheted doilies into squares she stitched together like quilts. Her fabrics became layered, with multiple openings and hand-stitched drawings, and she created ceiling to floor installations. Instead of painting on canvas, she made giant gossamer aprons that would give Betty Crocker a migraine.

Four such aprons form the "walls" of her house in "Thread Whisper," each one with its own distinct personality. Clearly they serve as metaphors for housebound women.

One is slightly worn. Another has transparent envelopes attached to it. Each envelope contains a handkerchief with one of Lee's stitched, organically outlined drawing of a person. "Someone has to open each one up and take them out. They can't get out by themselves," she explains.

Lee's drawing, as she calls it, consists of tiny stitches she painstakingly embroiders to form lines. Each little stitch, she says, "represents a seed that offers hope of personal growth."

In that spirit, Lee has created "gardens" in her installation. In one corner, the ground has been "furrowed" with hundreds of minute stitches sewn onto various kinds of fabrics that have been rolled, folded, stitched on, and dyed.. On another wall, dozens of embroidered circles or rings hover on the wall like so many butterflies or bubbles; they represent flowers blossoming and opening up. A profusion of crochet-work and molded paper shapes formed from doilies explode on a third wall like some giant fabric bouquet.

"Life is a bouquet – whether hard or easy," Lee believes. In her art, there is ever a push – pull sensibility. Lee's house of monster aprons threatens to smother one, yet as "walls" the aprons are transparent and open at the sides. There is a possibility of freedom. And ultimately, endless rows of plain little stitches can sometimes turn into vibrant works of art, just as a garden patiently tended can one day glow with color and life..

By Elisabeth Kirsch, Art Critic

Quote from the KC Star, June 28, 2009

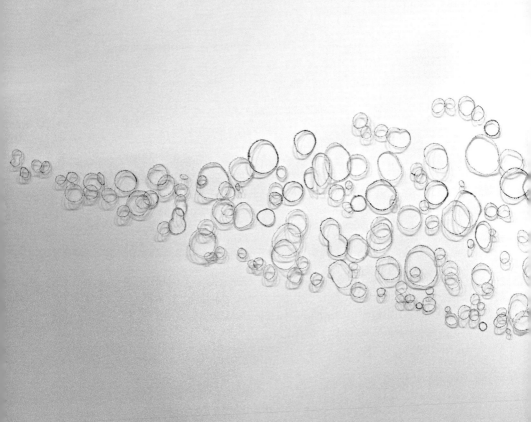

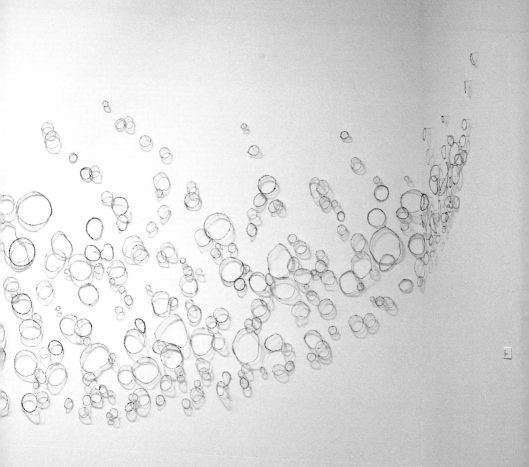

꽃다발 _Bouquet 3, 2009, hand embroidered thread, tarlatan, 536×150cm

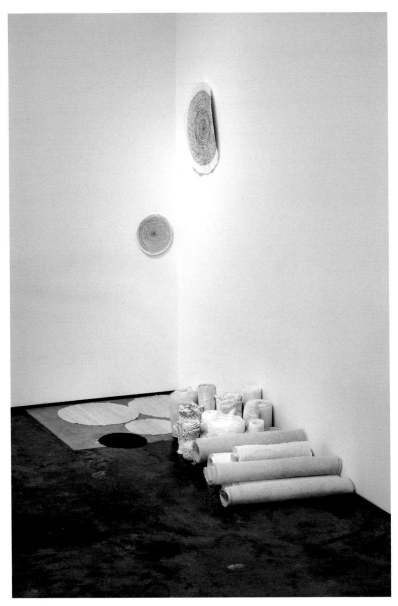

씨앗정원_Seedpod Garden, 2009, hand embroidered thread, vintage linen, 89×127×101cm

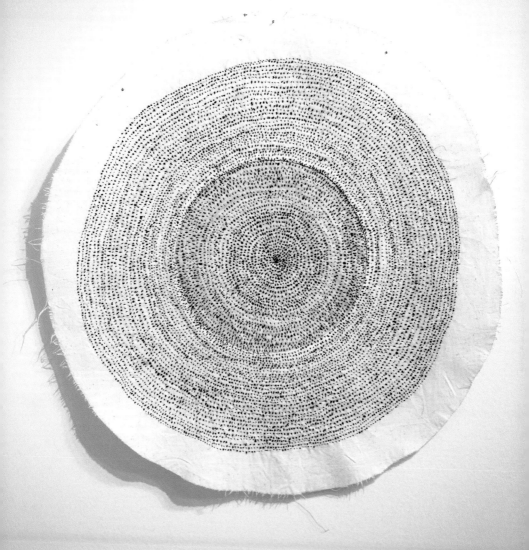

씨앗_Seedpods, hand embroidered thread, vintage linen, 51×51cm Private collection

창문

한국에서 자라날 적에 나는 전통적인
한옥에서 살았다.
창문은 아름다운 나무 창살
무늬로 구성되었고
반투명한 한지로 덮여있었다.

창문 종이에 구멍을 내는 것은
금지되어 있었으나
나의 호기심은 늘 손가락에 침을 묻혀서
구멍을 내고 창밖을 내다보곤 했다.
그리곤 어른들로부터 꾸지람도 들었다.

이 기억이 먼 훗날 미국땅에서 떠올랐다.
미술 전문 직업을 중지하고
가정부, 집사람, 엄마가 되어
조용한 주택가에서 아이들을 낳고 키울 때 였다.
어머니, 가정주부, 부인이 되어 일하는 것은
무척 보람되고, 즐거운 귀한 경험이었다.

한편 흥미있게 활동했었던 미술 세계에서 멀리 격리되었고,
그 세계 동정을 창문 구멍을 통해 내다보는 듯 했다.
이 같은 임신으로 '창문'을 출산하게 되었다.

▷Photo Credit_ Jimmy Cohrssen

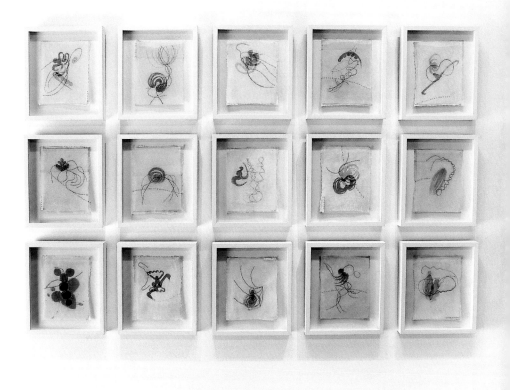

창문가에 여인들_Window women, 2009, hand embroidered thread, Korean paper, tarlatan, mixed media, 117×172cm, George Billis Gallery LA, Los Angels, CA

Window

When I was a growing up as a little girl
I lived in a traditional Korean Hanok house.
The windows were made of
delicately designed
wooden grid structures that
covered with transparent Korean paper.

Making holes on the Korean paper of window
of my room was forbidden.
But my curious mind always led me to make holes
with a wet finger to look outside and
scolded by an adult.

This memory was recalled later in the US
When my art career was on hold while
I became a full-time homemaker, wife, mother
and raising children in the suburbs.

It was very much rewarding and joyful experience,
but I also felt entrapment and isolation
seeing the art world through the window.
With such pregnancy, I gave a birth to the 'Window.'

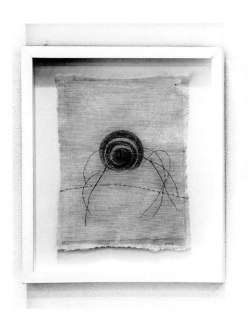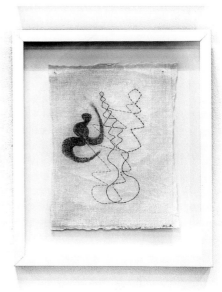

창문가에 여인들_Window women, 2009,
hand embroidered thread, Korean paper, tarlatan, mixed media, 35×30cm each

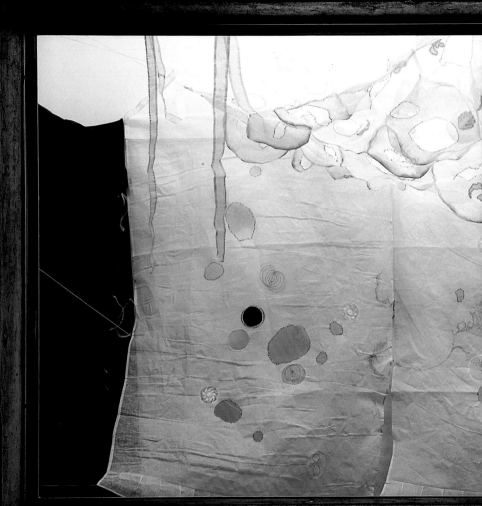

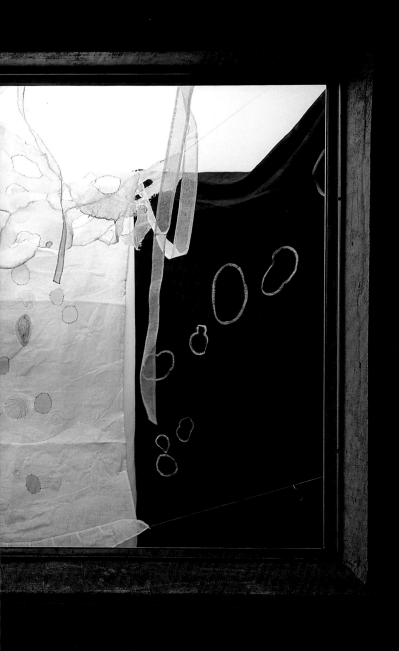

창문 Window, 2009, hand embroidered thread, mixed media,
window installation, 152 × 457 × 152cm
George Billis Gallery LA, Los Angeles, CA

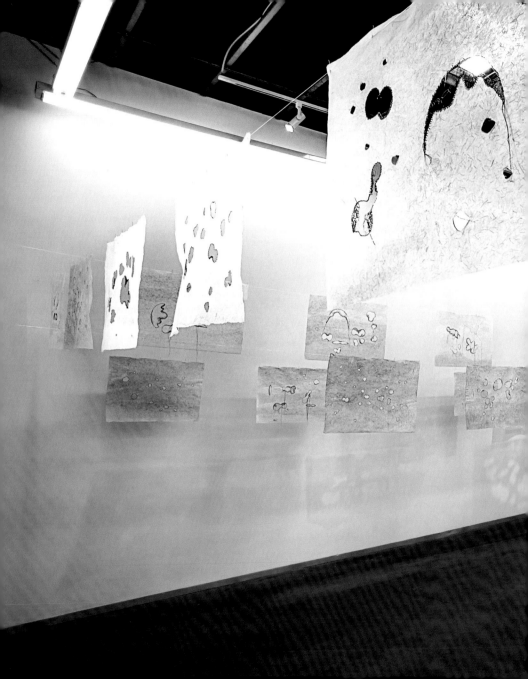

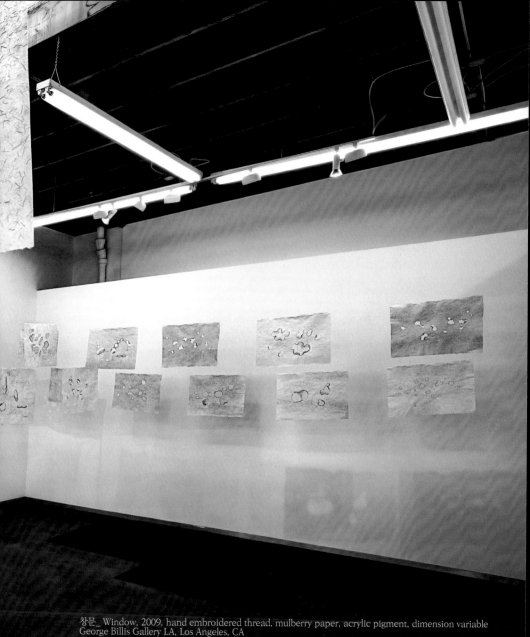

창문_ Window, 2009, hand embroidered thread, mulberry paper, acrylic pigment, dimension variable
George Billis Gallery LA, Los Angeles, CA

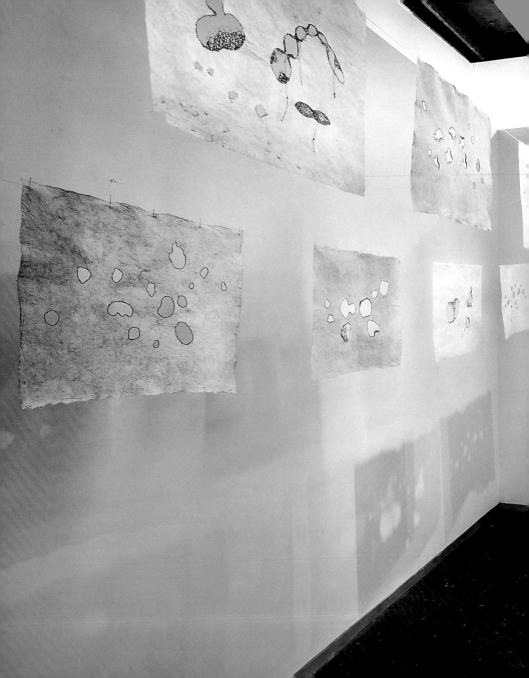

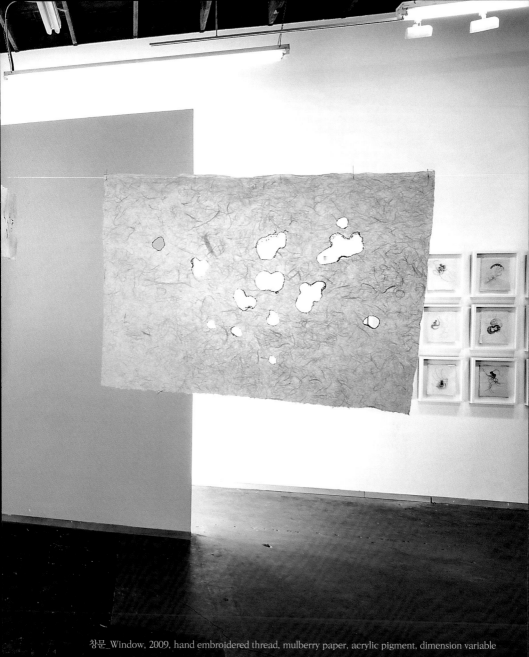

창문_Window, 2009, hand embroidered thread, mulberry paper, acrylic pigment, dimension variable

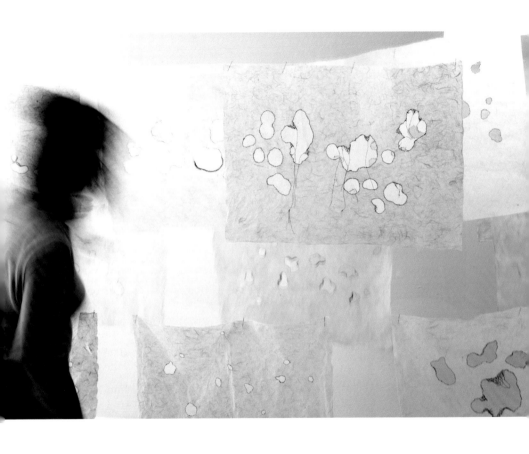

창문_Window, 2009, partial installation view, hand embroidered thread, mulberry paper, mixed media
Haunting Memories, Gallery Korea, Korean Cultural Service, New York, NY
In conjunction with Asian Contemporary Art Week, New York, Photo credit, E G Schempf

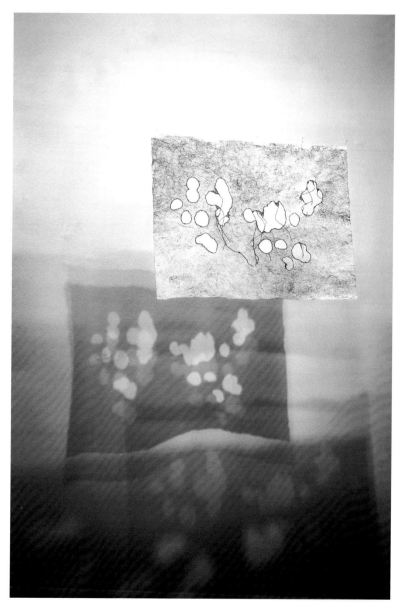

창문_ Window, 2009, hand embroidered thread, mulberry paper, mixed media, details

Photo credit, E G Schempf

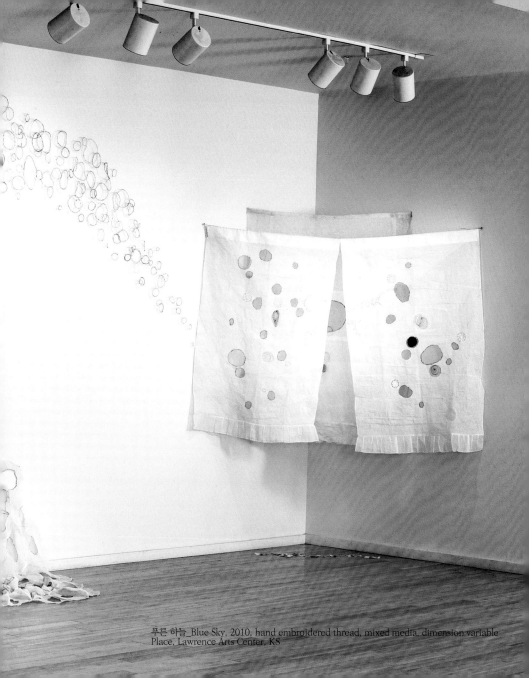

푸른 하늘_Blue Sky, 2010, hand embroidered thread, mixed media, dimension variable
Place, Lawrence Arts Center, KS

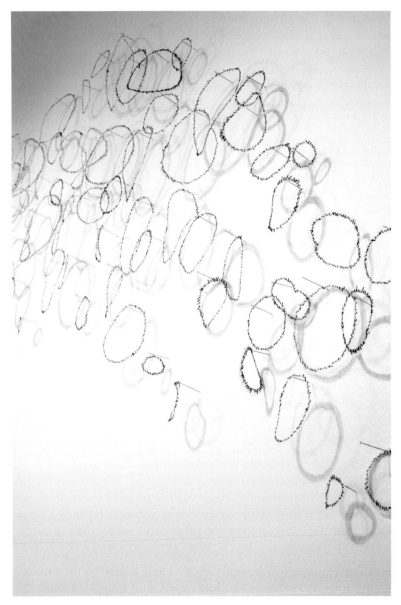

푸른 하늘_Blue Sky, 2010, details, hand embroidered thread, tarlatan

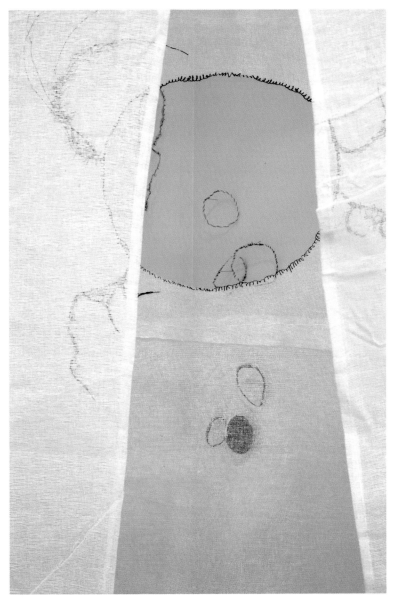

푸른 하늘_ Blue Sky, 2010, details, hand embroidered thread, mixed media

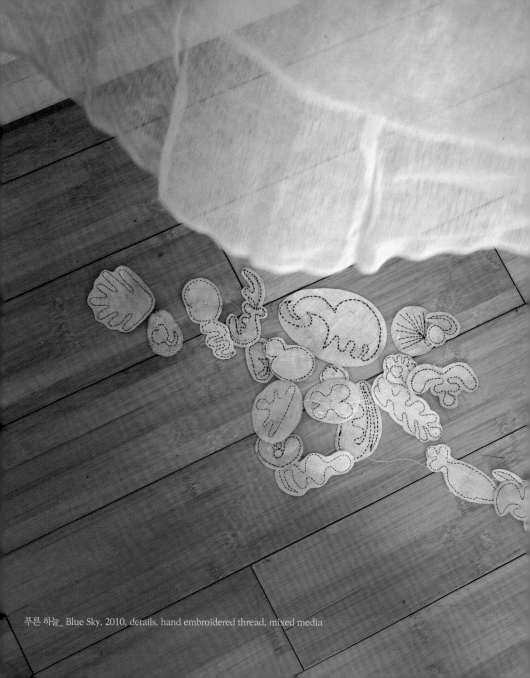

푸른 하늘_ Blue Sky, 2010, details, hand embroidered thread, mixed media

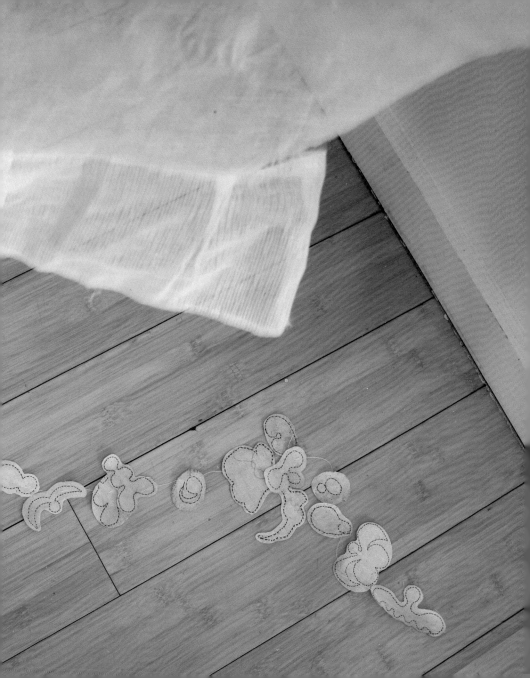

봄씨앗
Spring Seedpods

겨울정원_Winter Garden 2, 2000, calligraphy ink, clay, Korean paper, mixed media, 101×127cm.
Private Collection

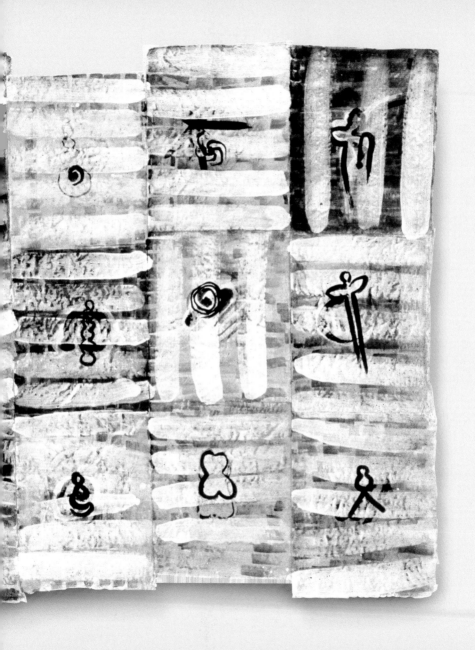

Ke-Sook Lee at Dolphin - Kansas City - mixed media exhibition

The materials and techniques used by Korean-born Kansas City artist Ke-Sook Lee speak of feminine delicacy and the domestic domain of house and garden. Grids of rice-paper squares punctuated by areas of stitching and little insets of lace and netting suggest quilts, while lacy edgings connote pillowcases and hand towels. A palette of quiet pastel hues and restful neutrals conspires to further this impression of feminine stereotypes. But the forms that emerge from the compositions, with their calligraphic evocations of seeds and flowers, insects aloft and abstracted figures, suggest a female determination and strength as unrelenting as nature itself.

...............Arrayed in a grid on the wall, "Hand Towels: Dye My Hands" (2001) comprises 24 slablike rectangles of handmade paper, tinted in soft shades of blue and brown and perforated by doilies and open netted areas. Fading in and out of these plasterlike surfaces are Lee's personal hieroglyphs of drawn and painted figural and insect forms.

Employing alternating squares of white tarlatan and plain rice paper, Awakening in Her Garden II (2001) is the most striking of several pieces to use the format of a patchwork quilt. Lee perforated the rice-paper squares with radiating patterns resembling the cutout snowflakes children make in school. On the tarlatan squares, motifs such as a tiny seed embryo or the head of a coneflower are calligraphically rendered in brown pigment that she derives from clay. Providing linear counterpoint, simple designs stitched in black thread flow over and around the painted images.

by Alice Thorson, art critic

Quote from Art in America, Jan, 2002

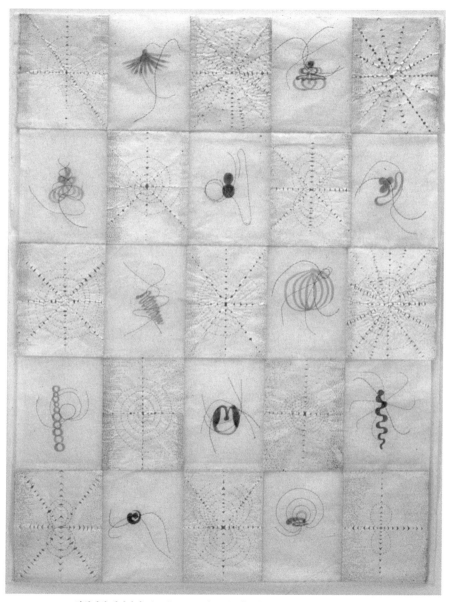

정원에서 깨어나다 _Awakening in her Garden 3,
hand embroidered thread, Korean paper, tarlatan, mixed media, 137×142cm
Collection Spencer Art Museum, University of Kansas

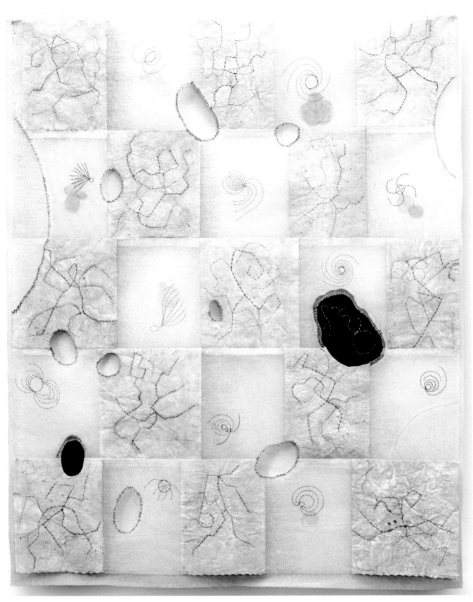

정원작업_Garden Toil, 2004, hand embroidered thread, Korean paper,
earth, tarlatan, mixed media, 74×97cm Private Collection

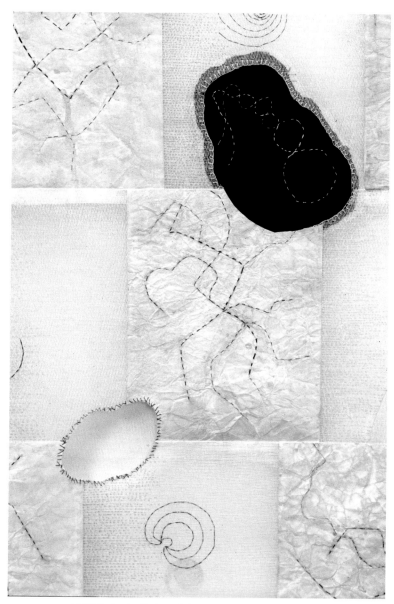

정원작업_Garden Toil, 2004, hand embroidered thread, earth,
Korean paper, tarlatan, mixed media, detail

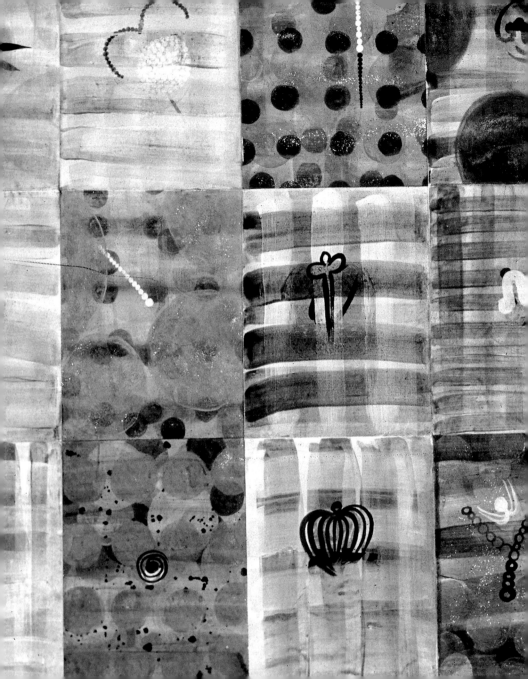

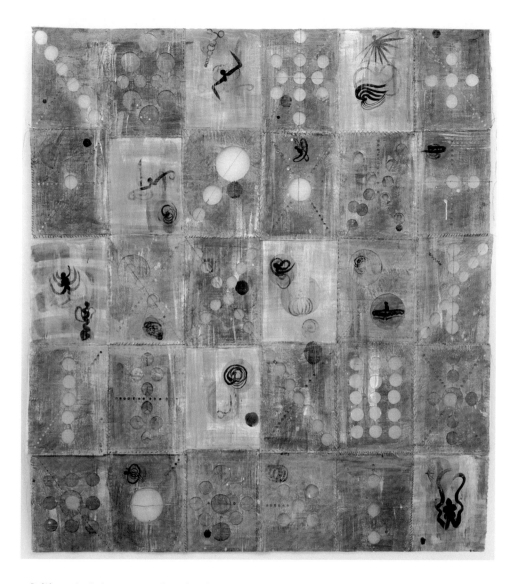

흙이불 _Earth Blanket 2, 2005, calligraphy ink, hand embroidered thread, clay,
Korean paper, mixed media, 134×147cm

◀정원의 꽃_Garden Flowers, 2002, details, calligraphy ink, earth, Korean paper, mixed media
Collection of Dewey Ballantine LLP, Los Angels, CA

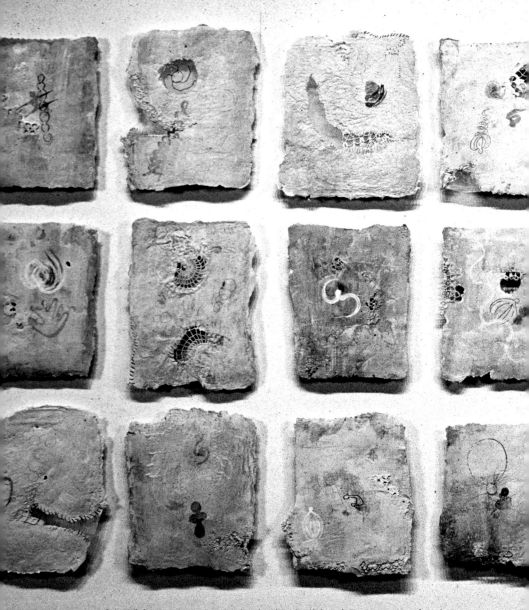

내 손 물들다_Dye my Hands, 2002, hand embroidered thread, Korean paper pulp,
vintage doily, mixed media, 213 ×102cm partial installation view

내 손 물들다_Dye my Hands, 2002, hand embroidered thread, Korean paper pulp,
vintage doily, mixed media, 25×33cm details, Private Collection, Photo credit_ E G Schempf

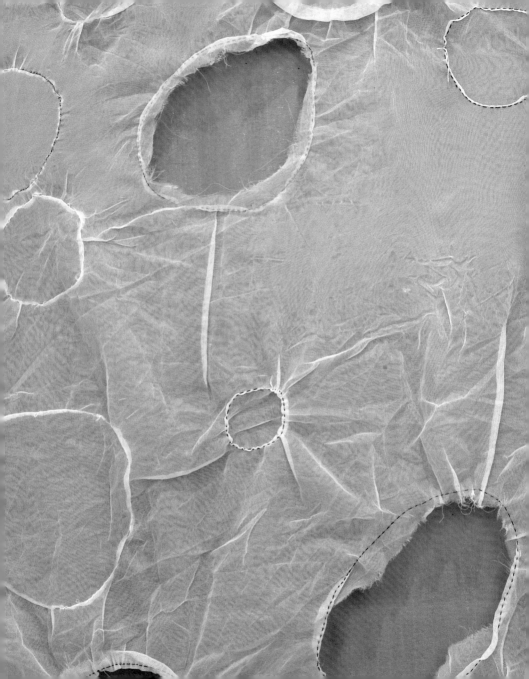

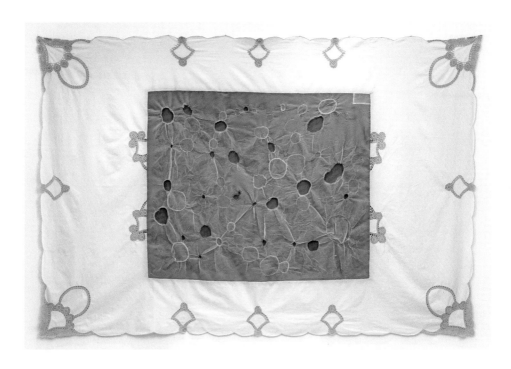

씨앗 상보_Seedpods Tableclothes, 2008, hand embroidered thread,
Korean woman's skirt, vintage tablecloth, details,

◀씨앗 상보_Seedpods Tableclothes, 2008, hand embroidered thread,
Korean woman's skirt, vintage tablecloth, 172×256cm,
Threading Trends Berlin, Alte Post, Berlin Germany

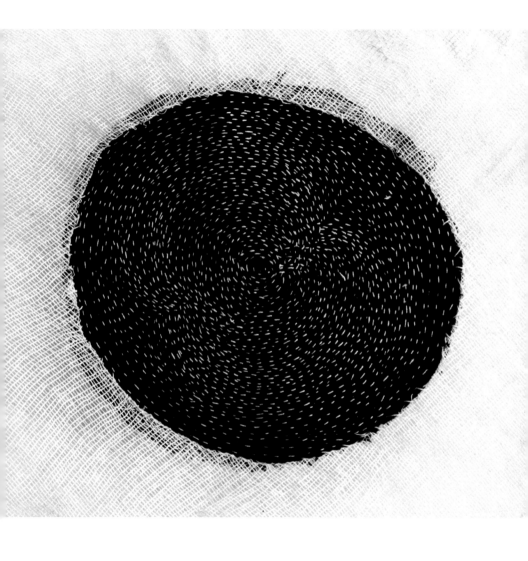

씨앗 _Seedpods 36, 2007, details, hand embroidered thread, mixed media

씨앗 _Seedpods 36, 2007, hand embroidered thread, mixed media, 42×77cm
Collection of Nerman Museum of Contemporary Art, KS. Photo credit, E G Schempf

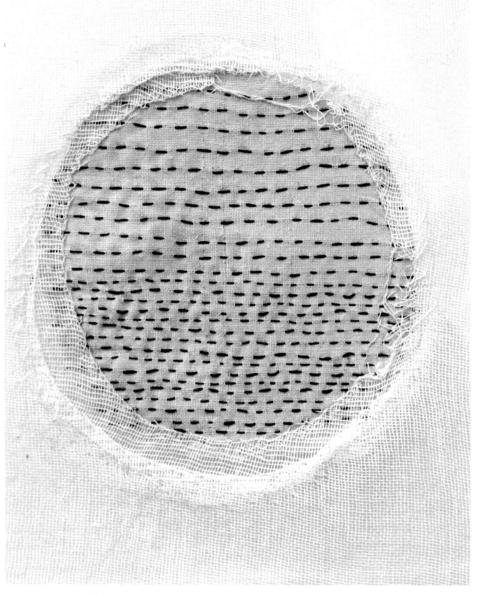

씨앗 _Seedpods 34, 2007, details, hand embroidered thread, mixed media

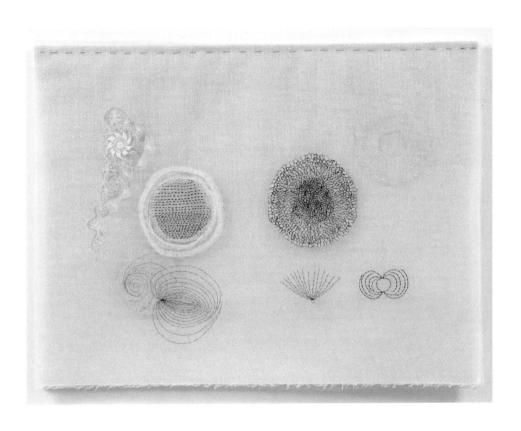

씨앗 _Seedpods 34, 2007, hand embroidered thread, mixed media, 42×77cm

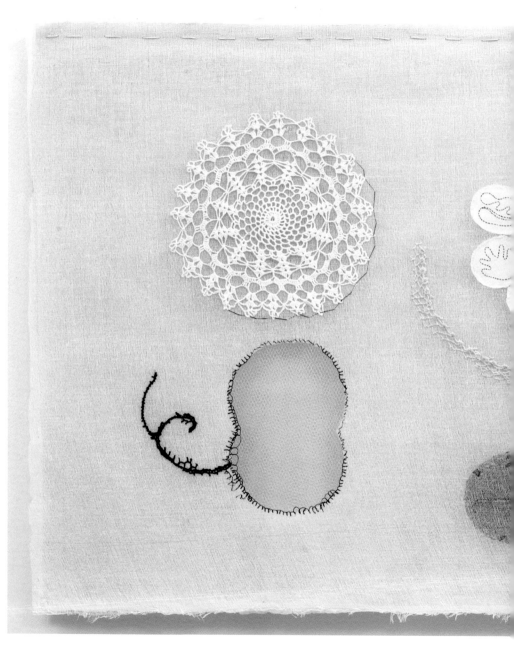

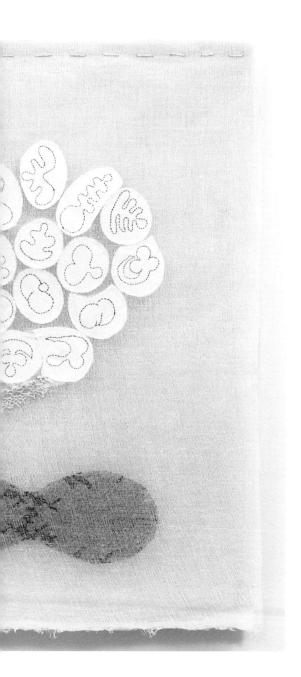

씨앗 _ Seedpods 37, 2007, hand embroidered thread, mixed media, 42 × 77 cm.
Collection of University Hospitals Seidman Cancer Center, Cleveland, OH

81

씨앗 _Seedpods 17 hand embroidered thread, tarlatan 2005 detail

씨앗_Seedpods 17 221×221cm hand embroidered thread, tarlatan 2005

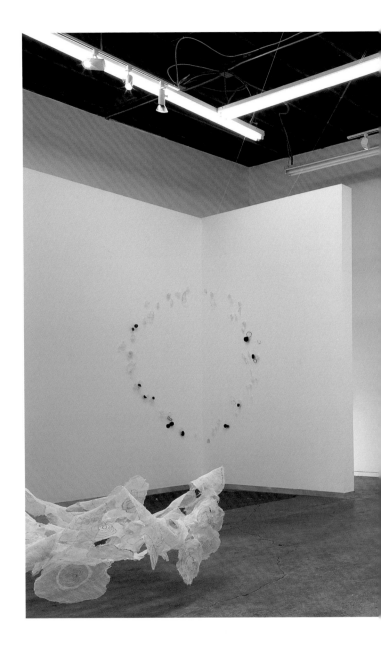

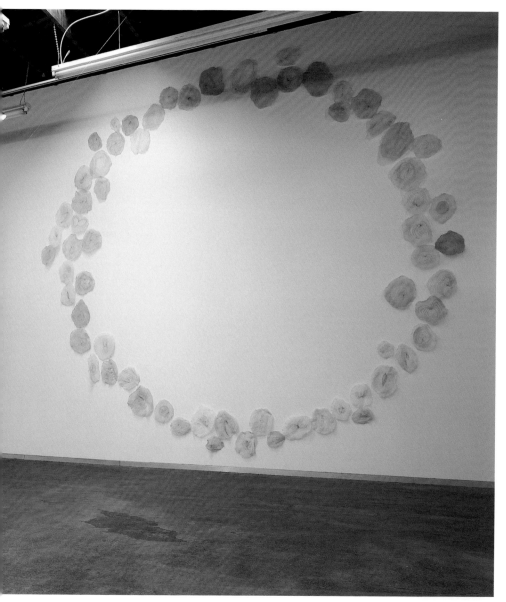

씨앗 _Seedpods 20 hand embroidered thread, tarlatan, earth 2005 dimension variable

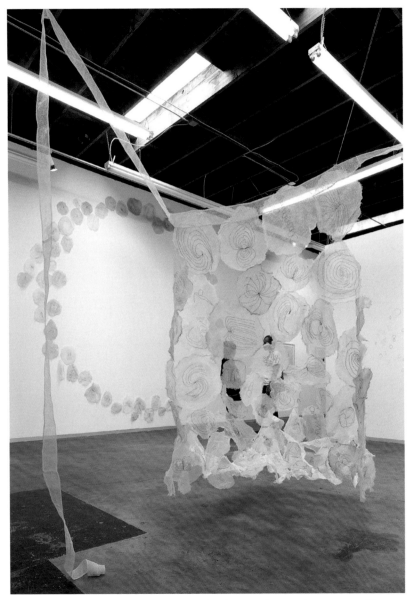

씨앗 _ Seedpods hand embroidered thread, tarlatan, earth 2005 dimension variable

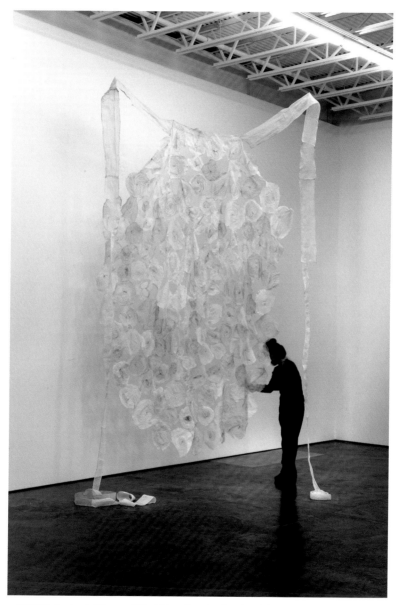

씨앗여인_Seedpods Woman 190×355cm hand embroidered thread, tarlatan, earth 2009

꿈꾸는 씨앗

소묘는 순수하고
솔직한 마음의 흔적
마음속 혼에서 열정적으로 튀어나온 모습.
전통적인 소묘재료를 떠나
실로 선, 점을 그리며
순수예술의 담장문을 활짝 열어본다

옛 부인들의 얼굴과 손을 만졌던 손수건
그녀들의 땀방울, 눈물, 콧물 들을
기억하고 있는 손수건을
깨끗이 씻고 말려 다림질하고
수를 놓아 여자 모습을 그리다

까만 점, 실매듭 하나씩 남기면서
그녀들의 꿈, 나의꿈
새싹이 솟아나듯
봉긋봉긋 튕겨나와 앉는다

손수건은 접히기도 하고
열리기도 하고
무한한 공간을 헤쳐가며 꿈꾸는
씨앗을 키우는 과정
꿈의 발자국.

꿈꾸는 씨앗_Dream Seedpods 34×180cm hand embroidered thread, vintage handkerchief 2012
Women to Watch 2012: Focus on Fiber & Textiles, Dean's Gallery, University of Missouri

Dream Seedpod

Drawing is pure
a trace of honest heart
which poured out of passion with spontaneity.

Exploring non traditional drawing media,
thread is used for mark marking device,
opening the boundary of art making.

The vintage handkerchief that had touched
and remembered women's face and hands
has washed, dried, ironed,
and embroidered a woman on it.

Black dot, thread dot, one by one
the dream that she dreamed and I dreamed
sprouts out new sprouts
swells out on the surface and swelled.
The handkerchief could be hold
could be opened
exploring endless space and times
cultivating the seedpods that dreams.

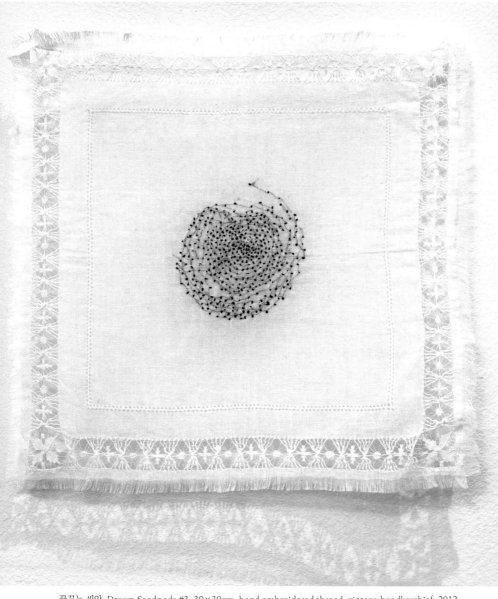

꿈꾸는 씨앗_Dream Seedpods #3 30×30cm hand embroidered thread, vintage handkerchief 2012
Photo credit_ E G Schempf, Private collection

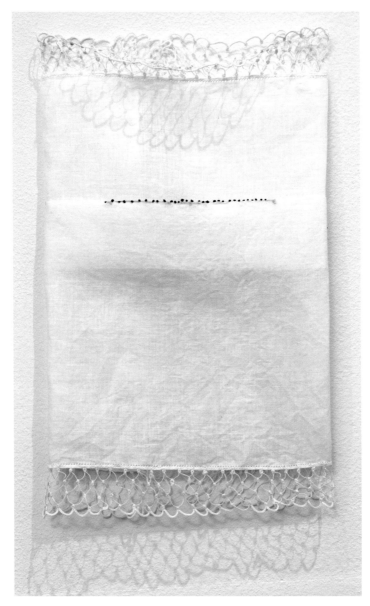

꿈꾸는 씨앗_Dream Seedpods 5, 19×34cm hand embroidered thread, vintage handkerchief 2012

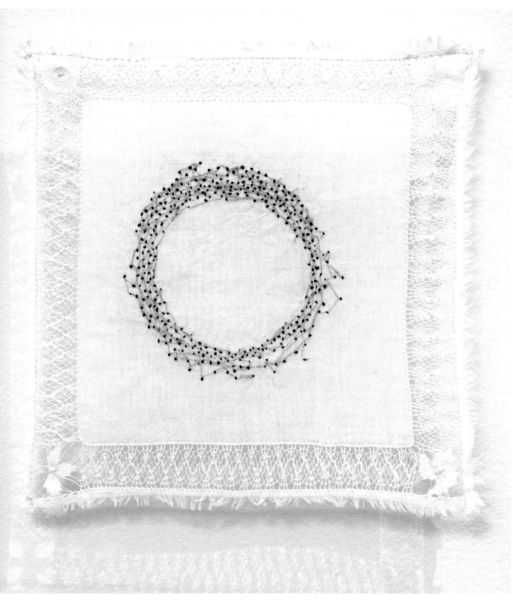

꿈꾸는 씨앗_Dream Seedpods 4, 26 ×26cm hand embroidered thread, vintage handkerchief 2012
Private collection

여름싹
Summer Sprouts

앞으로 내딛기

어느 무더웠던 여름날
천둥 번개 비가 쏟아져 숲의 나무들을 씻어냈다.
나무껍질들은 나무둥치에서 벗겨져
땅에 떨어져지고
나무는 껍질없는 벌거벗은 나무가 되었다.
이제 나무둥치는 더 크게 자라고, 껍질도 새로나와 커진 나무둥치를 덮겠지.
버려지고 커지는 자연 현상은
내기억을 되살렸다.

나는 살아오는동안 4세대 여인들을
우리가족과 사회에서 보아왔다.
각세대 여인들은 여자임으로 지켜야할
여러 종목의 억압하는
쓰여있지 않은 법칙으로
전세대에서 후세대로 전해 내려온,
울타리안에서 해방되려 애써왔다.

세대가 갈릴 때마다, 여인들은
한 발자국식 앞으로 진보 하며, 좀더 자유롭게
가정과 우리사회에서 성장하는 여인이 되었다.
이것은 나무가 껍질벗기며 자라듯
자연 현상으로 보인다.

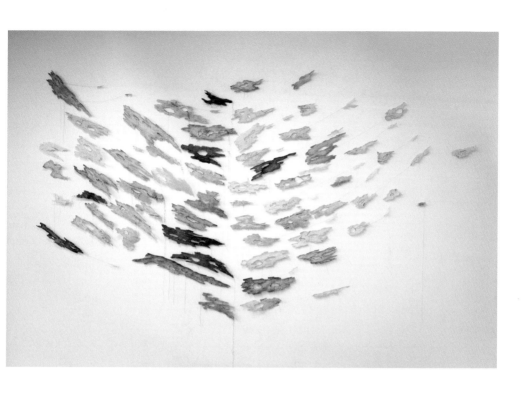

앞으로 내딛기_Stepping forward 2011, 304×244cm hand embroidered thread, mulberry paper, mixed media
George Billis Gallery, New York

Stepping Forward

One warm summer night
heavy thunderstorm showered the trees in the woods.
Next morning I saw the pieces of bark was stripped off
from the tree trunk and fallen to the ground.

The tree trunk became naked.
The tree will have new growth and new bark.
This natural process of the way of abandoning existing boundary
to have new growth recalled my memory.

I have seen four generations of woman
in our family and society.
Each generation of woman has struggled to
strip off unwritten rules of woman that bonded us
which has passed from older generation to next generation.

Each generation made one step ahead
for equal right and freedom for their growth and happiness
as an individual person in a family and our society.
It does seem so natural, like a tree
That stripped off for their growth.

▶앞으로 내딛기_Stepping forward, hand embroidered thread, mixed media 2011 detail

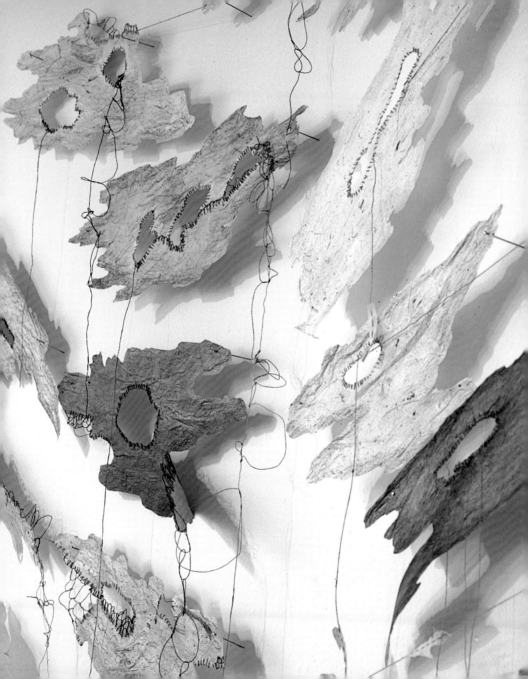

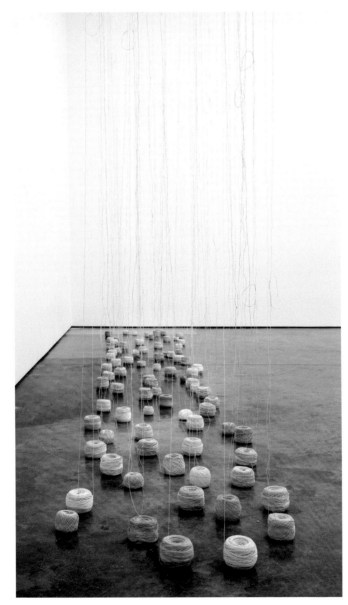

보슬비_ Drizzle 2, spooled thread, acrylic 2012 Dolphin Gallery, MO
Photo credit_ E G Schempf

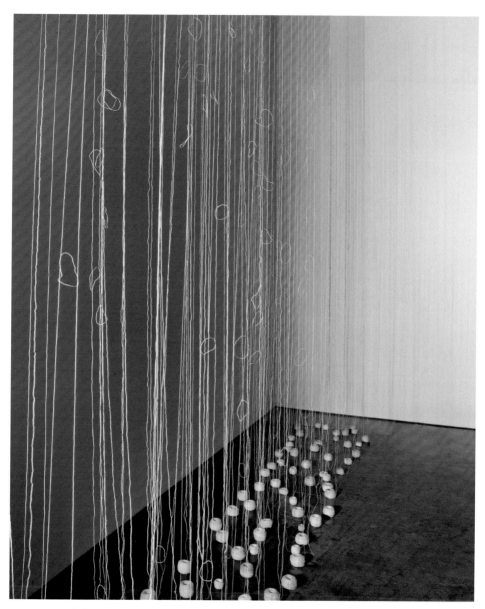

보슬비_Drizzle, spooled thread, acrylic 2012 partial installation view Dolphin Gallery, MO
Photo credit_ E G Schempf

하늘에서 꽃피다_ Blossoms in the sky, hand embroidered thread, tarlatan 2012 partial installation view

하늘에서 꽃피다_ Blossoms in the sky, hand embroidered thread, tarlatan 2012 partial installation view

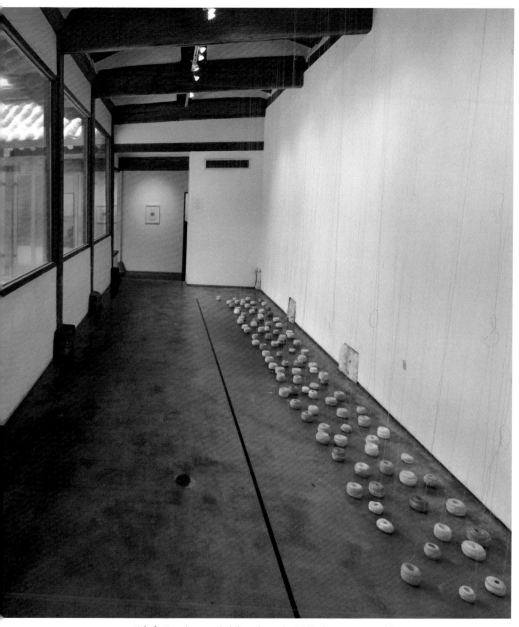

보슬비_ Drizzle, spooled thread, acrylic 2012, dimension variable
갤러리 아트링크 Gallery Artlink, Seoul

하늘에서 꽃피다 _ Blossoms in the Sky #6, 44×56cm hand embroidered thread, mixed media 2011
Private collection

하늘에서 꽃피다_ Blossoms in the Sky #5, 48×40cm hand embroidered thread, mixed media 2011
George Billis Gallery, New York

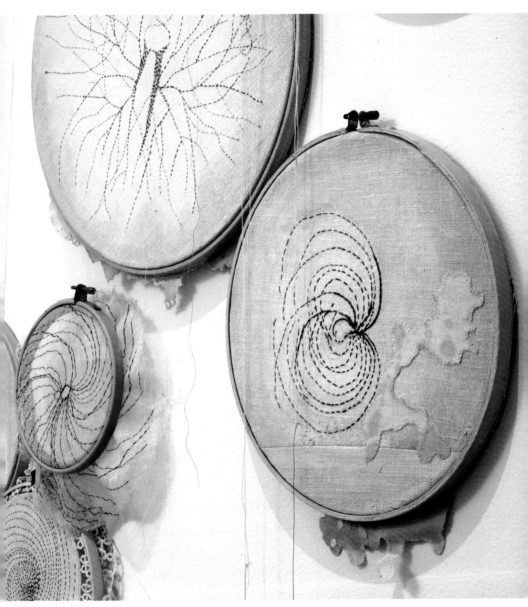

하늘에서 꽃피다_Blossoms in the Sky, hand embroidered thread, mixed media 2013 detail

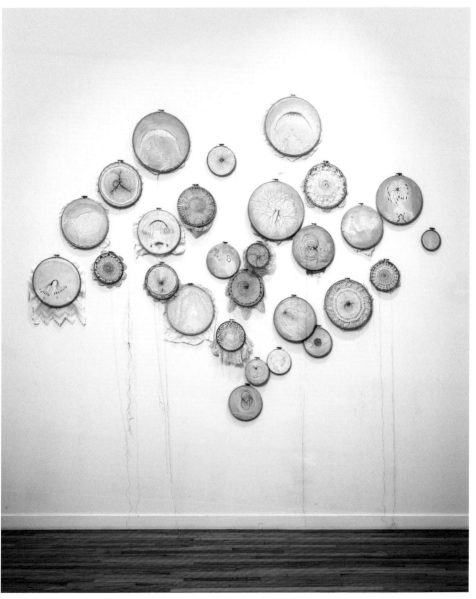

하늘에서 꽃피다_Blue Sky, hand embroidered thread, mixed media 2013 dimension variable
Watson Gallery Salina, KS

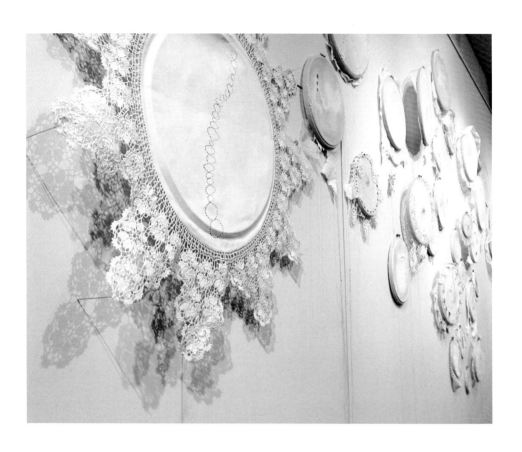

푸른 하늘 Blue Sky hand embroidered thread, mixed media 2014 dimension variable
박을복 자주미술관 Park Eul Bok Embroidery Museum, Seoul

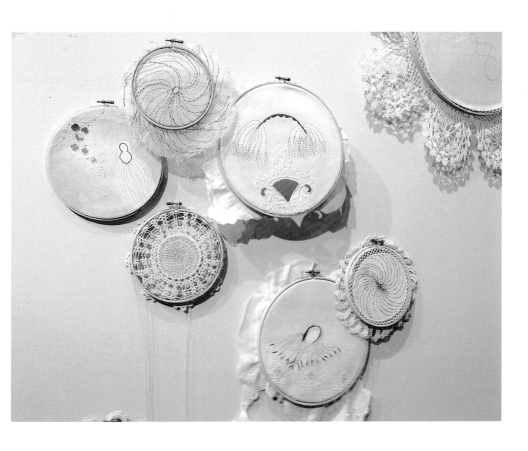

푸른 하늘 _Blue Sky, hand embroidered thread, vintage doily, mixed media 2014, detail

오계숙의 "얼굴 없는 100명의 여인들"

박영숙 | 트렁크갤러리 대표, 포토아티스트

한 가정의 일상적 삶이란 한 여성의 손길 없이 이루어지는 것은 단 하나도 없다. 그런데 오늘날 우리 시대 여성들에게 집안일이란 핸드폰의 예약 버튼만 누르면 빈집에는 누가 있는 듯 전구들이 켜지고, 부엌에서는 밥이 되고, 세탁기는 시간 맞춰 돌아간다. 신선한 먹거리가 주문 배달되고, 조상님 제사상도 며느리 손길 거치지 않고 정성스럽게 지어 올려진 상이 훌륭하다. 여성의 손길, 여성의 시간을 빼앗지 않고도 이 모든 일이 잘 돌아가는 세상이 바로 오늘이다. 옛 여인들은 꿈도 못 꾸는 그런 현실들이 우리 눈 바로 앞에 펼쳐진다.

나는 유럽 여성들의 일상 현실은 우리의 어머니 세대가 겪어 낸 세상과는 다를 줄 알았다. 그런데 그렇지 않았다. 페미니즘 텍스트들이 전해주는 그 많은 글을 살펴보면 어찌 된 것인지 우리보다 진보한다는 그들의 사회문화가 그들 여성에게 가한 많은 사건을 보면, 우리 조선의 여성들보다 더 억압된 삶이었고, 그 수많은 차별문화는 끔찍했었던 여성들의 삶을 전하고 있는데 그 어둠이 드리워졌던 이야기들이 바로 페미니즘 텍스트의 중심논의 거리로 이루어져 있었다. 중세 마녀사냥 이야기들이 그 것들이다.

작가 오계숙의 작업 "얼굴 없는 100명의 여인들" 작품을 보면 서구여성들의 꼼꼼하고, 섬세하고, 치밀함의 극치를 이루는 '손수건'들을 만나게 되는데, 그 훌륭한 솜씨의 '손수건'은 미술관에 있어야 했던 것들이 벼룩시장에 모퉁이에 굴러다니고 있었다는 슬픈 이야기를 갖고 한 작업들이다.
어려서 어머니가 가르치는 대로 따라 했던, '손수건 가장자리 꾸미기'를 나도 했었다. 흰 아사천을 일정크기의 정사각형으로 자르고, 그 네 면 둘레에서 네다섯 줄의 실올을 뽑아내고, 한 면의 씨줄을 뽑으면, 다른 면에서는 날줄을 뽑아 네 면을 바느질 방식으로 꾸미기를 갖춘다. 바느질은 씨줄이 뽑힌 곳의 날줄들을 엮어 모양새를 갖추고, 날줄을 뽑은 쪽은 씨줄을 모양낸다. 이 '손수건'태의 '가장자리 꾸미기'는 다양한 모양들로 찬란하다. 그 후, 다시 손수건의 중심에 예쁜 수를 놓아, 그 누구의 것과 다르게, 또 이야기를 느끼게, 그리고 더 정성스러운 내 마음 전하는 수단이 되었다. 그렇게 만든 손수건을 소중한 누구에게 선물하던 풍습은 나와 같은

연배인 오계숙의 소녀 시절을 대변하는 문화였다.

오늘, 이 '손수건'이야기, 온갖 정성과 멋진 디자인된 아름다운 '수공예품'인 이들 손수건은 작품으로의 대접을 받아 마땅했다. 그런데 오계숙 작가 40세가 되어 겨우 자신의 정체성을 확립해, 두근거리는 마음과 마음 깊이 간직했던 끝 모를 욕망의 화신, 오계숙의 눈에, 미국과 유럽의 벼룩시장 모퉁이에서 굴러다니는 '손수건'들을 운명같이 만났다. 그녀는 자기 자신을 본 듯 부르르 떨었을 것 같다. 옛 여성들의 노력 산물, 그녀들의 손짓, 그 아름다운 산물이 폐기된 모습으로 다루어지고 있는 그 현상들에 경악했을 그녀 모습이 보인다. 여성들의 작품이기에 미술관에 들어가지 못한 오늘의 페미니스트들의 차별 받음과 같은 맥락을 읽었으리라 생각도 같이 떠오른다. 그녀가 주섬주섬 주워 모아 구입 한 그 꼬질꼬질한 손수건들을 거듭 태어나게 하기가 시작된 것이다. 그 '손수건'들을 끌어모아 집으로 가져와, 빨고, 화학처리 해 보존력을 강화하고, 다듬질해 내, 새로 태어나게 하기 작업, 다시 관심 끌기, 새 의미를 지어내기, 새롭게 논의선 상에 끓어 올리기, 가 시작되었던 것이다.

오계숙의 이 손길은, 그 옛 여인들, 그 "얼굴 없는 여인 100인의 손길"에 '주목하기'를 시작했던 것 같다. 그 '손수건'의 용도로서 본 것이 아니라, 그 오브제에 담아낸 이미지들의 의미들을 재해석해 내며, 그 옛 여인들의 마음 읽기를 하였다. 우리 시대에 새롭게 인정해 내려는 뜻을 품고 있는 그녀, 그 이미지들 위에 자신의 마음을 전달하며, 상징의 모습과 환상의 모습으로 거듭나게 하기를 수를 놓고 있다.

"나는 내 개인의 경험에서 얻은 옛 여인들의 현실을 안타깝게 여겨, 그녀들의 '트라우마 trauma'를 치유시켜 주고 싶다. 나의 상징적 이미지는 '씨앗꼬투리'로, 오랫동안 숨죽이고 있던 생명체가 거듭 탄생하여 파란 하늘을 다시 보게 하고 싶은 마음에서 파란 하늘을 향하는 씨앗들을 그려 넣었다. 무수히 서로 다른 '씨앗'들을, 그리고 파란 하늘과 파란 호수들을 드넓게 그려 넣었답니다."

오계숙은 자수 실로 옛 여인들의 손수건 위에 한 땀 한 땀 수놓는 과정에서, 그 묵상 과정에서, 그 무아지경에서, 그 순간의 무의식에서, 자동으로 튀어나오는 이상한 모습의 여자들이, 매 순간마다 탈바꿈 하는 느낌을 보았다고 말한다. 그녀들이 내 작업 과정에서 씨앗 모습으로, 큰 나무로, 꽃으로 피어날 그 가능성과 그 희망을 보려고 나는 이 작업을 한다. 라는 그녀의 이 말은 아직도 이 작업은 계속되고 앞으로 더 이어나갈 것이라는 말이라 싶다. "얼굴 없는 100인의 여인들"은 아직 다 태어나지 못한 것 같다.

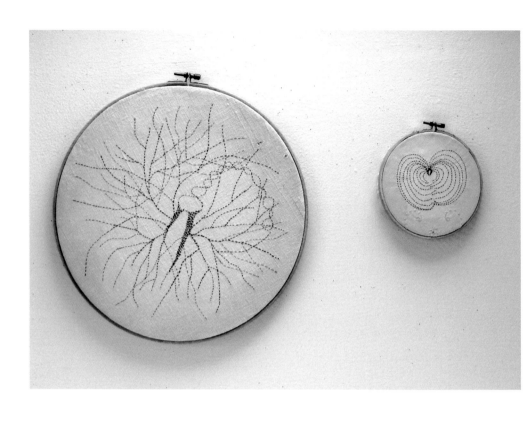

꽃나드리춤_Flower Stroll Dance, hand embroidered thread, mixed media 2013, detail

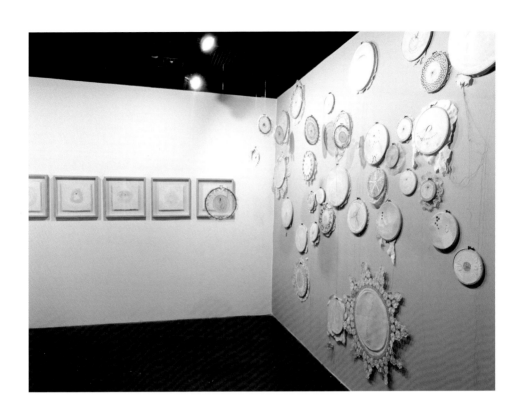

꽃나드리춤_Flower Stroll Dance, hand embroidered thread, mixed media 2015, dimension variable
트렁크 갤러리 _Trunk Gallery, Seoul

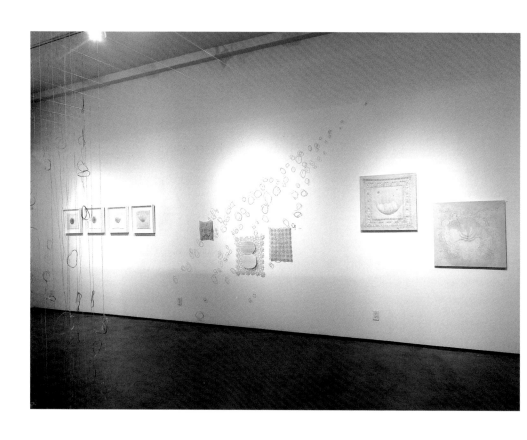

새싹 벽설치_ Ode to Sprouts wall, hand embroidered thread, mixed media 2015
George Billis Gallery, New York

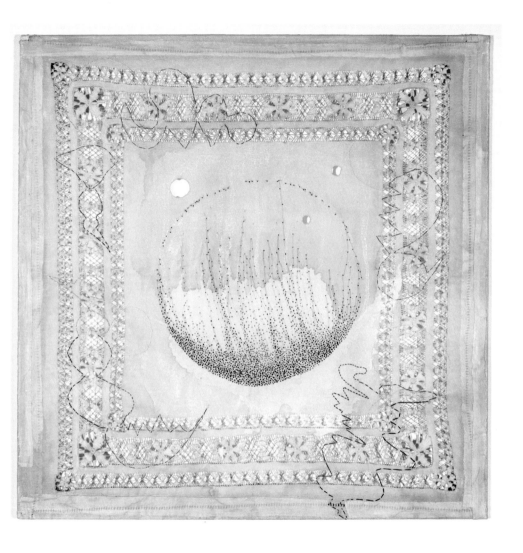

새싹노래_Ode to Sprouts #6, 66×66cm hand embroidered thread, vintage tableclothes, acrylic 2015

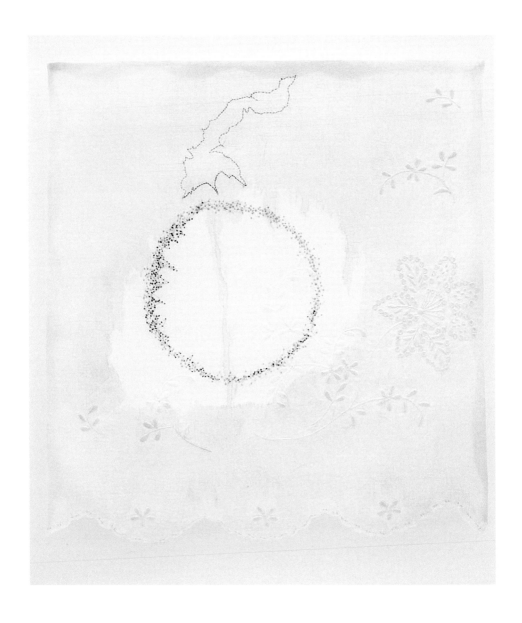

새싹노래 _ Ode to Sprouts #5, 38×41cm hand embroidered thread,
vintage tableclothes, mixed media 2015

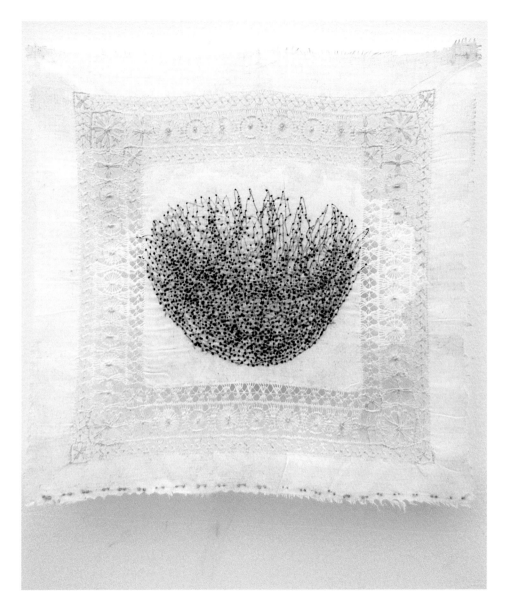

새싹노래 _Ode to Sprouts #2, 28×28cm hand embroidered thread, vintage handkerchief, acrylic 2015

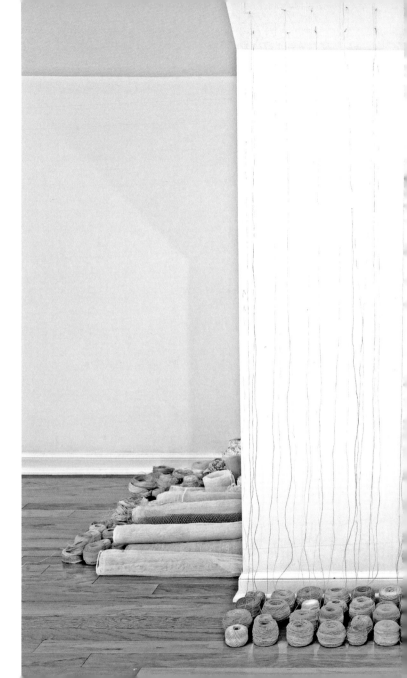

새싹노래_Ode to Sprouts, spooled thread, acrylic 2013 dimension variable
Photo credit, E G Schempf

118

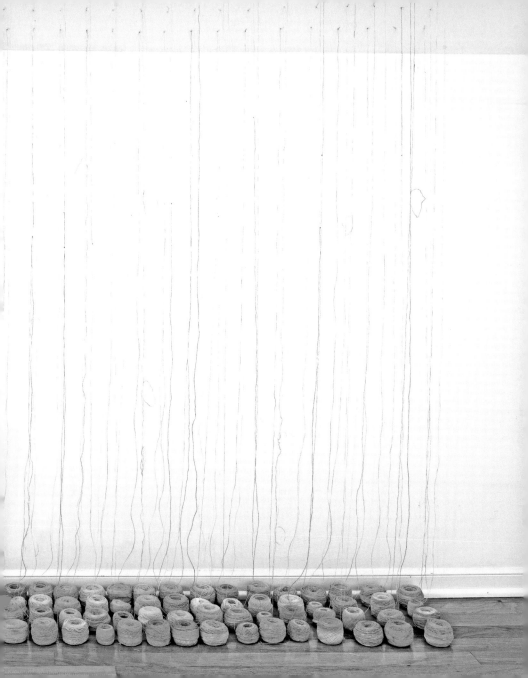

"Making the Threads Dance: Ode to Sprout II, an Installation by Ke-Sook Lee"

Kris Imants Ercums

Ode to Sprout II is composed of varied shades of blue thread—occasionally punctuated with yellow—that sprout upward from neatly bunched spools, assuming an organic temperament like plants reaching for the sky (fig. 1).1 When I first encountered Ode to Sprout at Ke-Sook Lee's studio on the eve of her departure from Overland Park, Kansas to her new home and studio in Berkeley, California, the threads danced. I was mesmerized… what magic had she deployed to compel the threads to grow, twirling and spinning in graceful loops as they reached for the sky?

The blue-and-green palate of the spools used in Ode to Sprout II evokes an archaic style of East Asian landscape painting known in Korean as cheongroksansu hwa 청록산수화 (Chinese: 青绿山水画 qinglu shanshuihua) or "blue-and-green" landscape.2 This fantastical style first emerged as early as the 7th century in China, and when utilized by artists in proceeding centuries, the blue-green landscape not only evoked deep antiquity, but a world in harmony.

While the blue-green hues of Ode to Sprout II reference East Asian landscape painting, for Lee the cerulean palate is also deeply related to her personal transformation as an artist. At the Spencer, Ode to Sprout II was displayed in conjunction with two other works by Lee. The 2001 work Awakening in Her Garden 3 mirrors Lee's transformation as an artist. Much of Lee's work diverges from her background in two countries: Korea

1 *Ode to Sprout II* was commissioned as part of the exhibition *Holding Pattern: New at the Spencer Museum* (10/09/2014—03/21/2015).
2 See further, National Museum of Korea, *Ch'ongnok sansu, nagwon ul kurida: Kungnip Chungang Pangmulgwan sojang Choson sidae ui ch'ongnok sansuhwa* [Dreaming of paradise: blue-green landscape paintings from the Joseon Dynasty at the National Museum of Korea], (Seoul: Kungnip Chungang Pangmulgwan, 2006).

and America. Her work also celebrates her role as a mother, homemaker, and gardener. As a child, Lee shared a room with her grandmother and great-grandmother, both of whom were expert needlewomen and taught her to sew by darning socks. After receiving a B.F.A. in applied art from Seoul National University in 1963, Lee and her husband immigrated to the United States. In 1982 she received a second B.F.A. in painting, from the Kansas City Art Institute. Awakening in Her Garden 3 is constructed of tarlatan–thin muslin, which is used as a stiffening fabric in garments. Inspired by quilting–Lee has an amazing personal collection of handmade American quilts–Lee stitched together pieces of Tarlatan and paper in a grid in which she brushed organic glyphs evocative of East Asian calligraphy. Each symbol is tied to her growth and personal development as an artist, as she "awoke in her garden."

Lee's artwork is also informed by the process and materiality of sewing—an occupation often derided as "woman's work." In her One Hundred Faceless Women series of hand-embroidered thread and pigment on vintage handkerchiefs, that these personal remnants of cloth touched the faces of countless, nameless women, held great spiritual power for her.3 Elisabeth Kirsch observes: "One can almost hear the polyphonic utterances of those who fashioned the delicate, hand-made handkerchiefs."4 For this reason, I intentionally included a late Joeson bojagi보자기, a traditional Korean wrapping cloth that is embroidered and composed of remnants of cloth sometimes from the very hanbok, or traditional gowns of a Korean woman, in order to underscore how Ke-sook Lee's artistic practice is situated in relationship with the legacy of Korean traditions.

Lee's use of repurposed material achieved monumental potency in Green Hammock (2010).5 Constructed from U.S. Army nurse's uniforms dating from the height of the Vietnam War in the 1970s, Green Hammock both conveys the trauma and horror of loss, while its "hammock" shape conjures a protective cradle. Lee encountered the uniforms at an Army surplus store not long after 9/11 and recalls being struck by the way the fatigues were torn, marked, and missing buttons; thus suggesting the combat experience that the nurses who wore them had endured. Initially Lee set out to create a camouflage net, like those used during the Vietnam war; however, as she progressed, the piece evolved into a hammock. For Lee, the hammock represents a place of temporary respite and restoration

3 Elisabeth Kirsch in *One Hundred Faceless Woman,* (self-published catalogue: 2012), no page number
4 . *Ibid.*
5 After viewing *Green Hammock* in Lee's studio in 2012, SMA director, Saralyn Reece Hardy and I successfully proposed that the Spencer Museum purchase the work for the collection, after which it entered the SMA permanent collection under the credit line: "Museum purchase: R. Charles and Mary Margaret Clevenger Art Acquisition Fund and East Asian Art Acquisition Fund, 2012.0075."

from the horror and trauma of warfare. The hanging threads and patches of fabric act as, what Lee terms: "dream remnants." By evoking the human form, Green Hammock functions as both a powerful testament to the often overlooked role of army nurses while also acting as a striking rumination on the trauma of war.

Lee's sensitive engagement extends to her exploration of the natural world, manifest in potent symbols of origin—seeds, eggs, and nests—in her work. She once turned to me and said that there came a point when she couldn't hide her irrepressible need to make art…"it was like a mouse's tail." As Ke-Sook Lee, installed Ode to Sprout II at the Spencer Museum in 2014 she laughed and danced the whole time, charming the threads to stretch to the ceiling above and celebrate the potent marvel of life.

Ke-Sook Lee's work Green Hammock is constructed from US Army Nurse's uniforms dating from the Vietnam War. Lee discovered the uniforms at an Army supply store, and recalls being struck by the way they were torn, marked, and missing buttons. This history of wear further reflects the experience of the nurses who wore them. Initially begun as a camouflage net, the piece eventually took on the shape of a hammock, representing a place for temporary respite and restoration from the horror and trauma of warfare. With hanging threads and tentatively stitched patches of hanging fabric (what Lee called "dream remnants"), through its evocation of the human form, the work is a powerful exploration of the role of army nurses and a larger rumination on war as it resonates in current affairs.

The art of Ke-Sook Lee mirrors her life. She draws inspiration from the duality of having roots in two countries, of practicing as a professional artist while relishing the role of mother, homemaker and gardener. As a child Lee shared a room with her grandmother and great-grandmother, expert needlewomen who passed their skills onto her. After receiving a B.F.A. in applied art from Seoul National University in 1963, Lee and her husband immigrated to the United States. In 1982 she received a second B.F.A. in painting, from the Kansas City Art Institute.

Motherhood interrupted Lee's career, it also became the springboard for her future artistic direction. Abandoning drawing and oil painting for calligraphy on rice paper, she then took up stitching and embroidery. The domestic sphere—sewing, mending, ironing and tending to house and garden—is the underlying theme of each of her creations. Her preferred material is tarlatan, a sheer plain-woven cotton, heavily sized for stiffness. It serves as the foundation for her multilayered collages, but is itself manipulated to convey directional lines through sharply ironed creases. She explains:

My work explores boundary of drawing, adopting common marks from everyday life as drawing mark such as worn holes, mended holes, wrinkles and folded marks and layered doily marks on wet pulp. Holding sharp needles like a pen, thread follows the needle pricks in and out of the fabric leaving the dots. Each dot stays in line and accumulation of lines create form until it gives a meaning. These forms are personal symbols and transfigured image of women from my experience of mother, wife, homemaker and an individual artist.

I learned hand embroidery and sewing from my grandmother and great grandmother. They did not know how to read or write like most of the women of her generation in Korea, but knew how to express their impassioned thoughts through embroidery. My work is inspired by their graceful endurance and creativity. Holding my inheritance in one hand and reaching out to contemporary drawing with the other hand, my work continues freeing itself from the boundary of art making, cultivating to find my identity and feminine aesthetics.

While this work present its own installation and storage challenges with regard to our current space constrictions, it represents one of the most important works in Lee's body of work. Saralyn and I had the pleasure to view it in her studio recently and in consultation with the artists, feel this is among her strongest works. Furthermore, the work relates to our strong holdings in textile, in particular the history of quilting, which includes a comprehensive sampling of Yoshiko Jizenji, and other contemporary fabric art. Finally, its exploration of and meditation on war and conflict, in particular the healing role of women, is charged with tenderness, a haunting sense of loss, and personal transcendence.

Kris Imants Ercums, PhD

Curator of Global Contemporary and Asian Art

The Spencer Museum of Art, University of Kansas

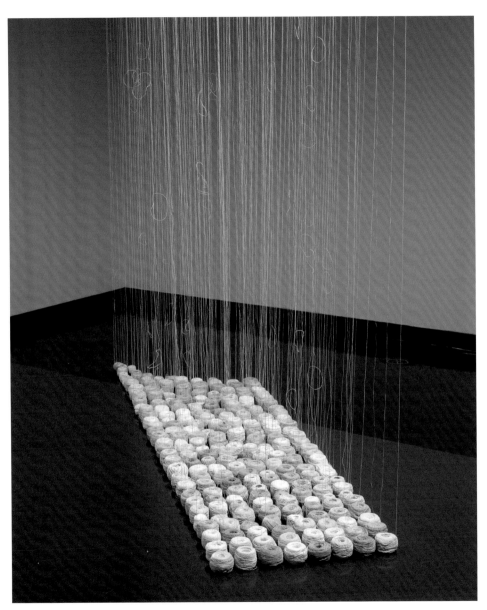

새싹노래 _Ode to Sprouts II, spooled thread, acrylic 2014 dimension variable
Spencer Museum of Art, University of Kansas, Photo Credit, Scott Anderson

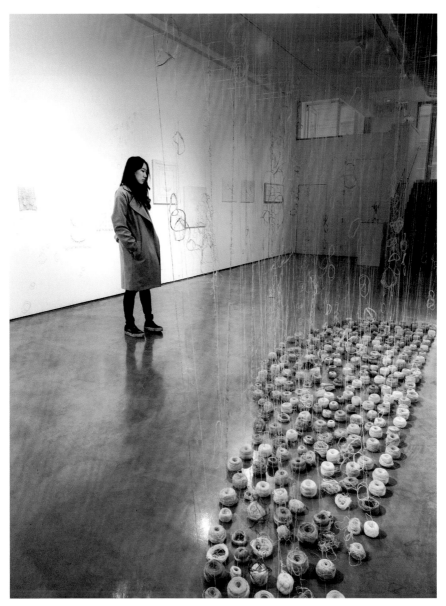

새싹노래 _Ode to Sprouts III, spooled thread, acrylic 2015
George Billis Gallery, New York

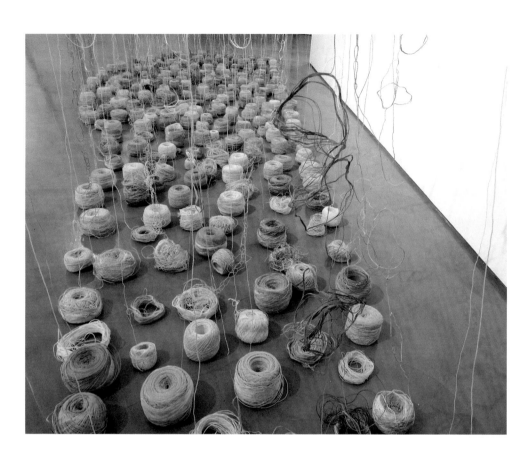

새싹노래_ Ode to Sprouts III, spooled thread, acrylic 2015 detail
George Billis Gallery, New York

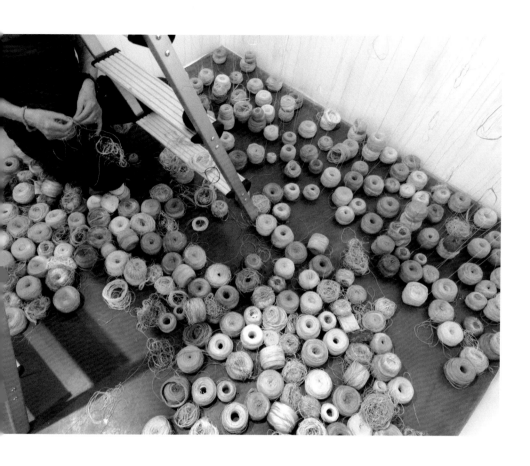

새싹노래 _Ode to Sprouts IV, spooled thread, acrylic 2015 트렁크 갤러리_ Trunk Gallery, Seoul

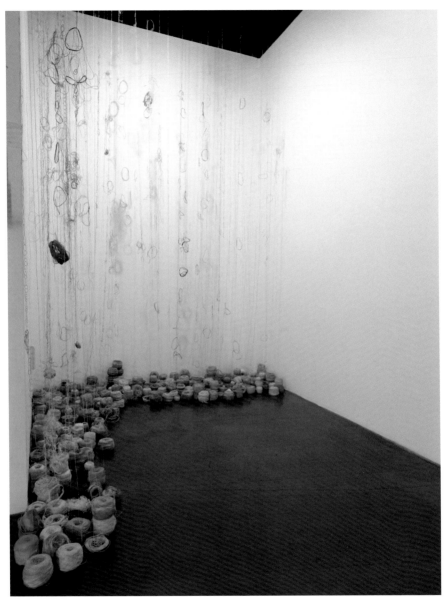

새싹노래 _Ode to Sprouts IV, spooled thread, acrylic 2015 dimension variable
트렁크 갤러리_ Trunk Gallery, Seoul

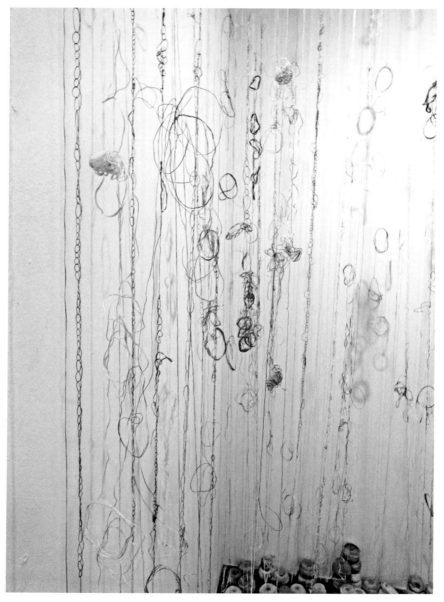

새싹노래_ Ode to Sprouts IV, spooled thread, acrylic 2015 detail

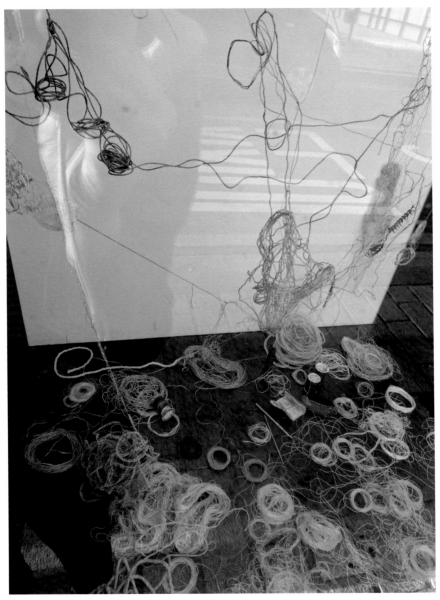

그녀의 방_Her room, 242×106×82cm thread, mixed media 2015
트렁크 갤러리 _ Trunk Gallery, Seoul

그녀의 방_Her room, thread, mixed media 2015 detail

구름꽃_Blossomed Clouds, hand embroidered thread, tarlatan 2015 dimension variable
트렁크 갤러리_Trunk Gallery, Seoul

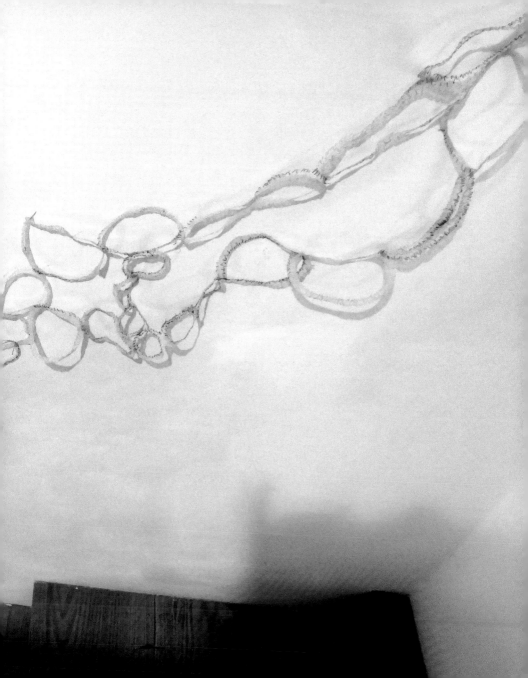

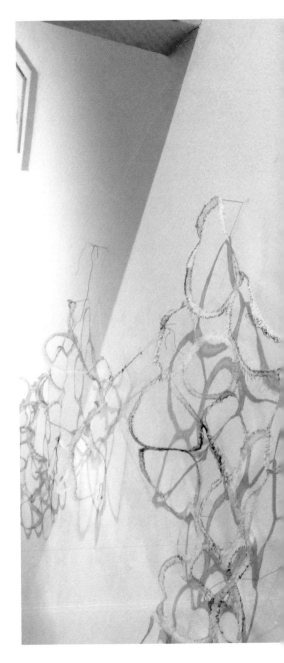

구름꽃_Blossomed Clouds, hand embroidered
thread, tarlatan 2015 partial installation view

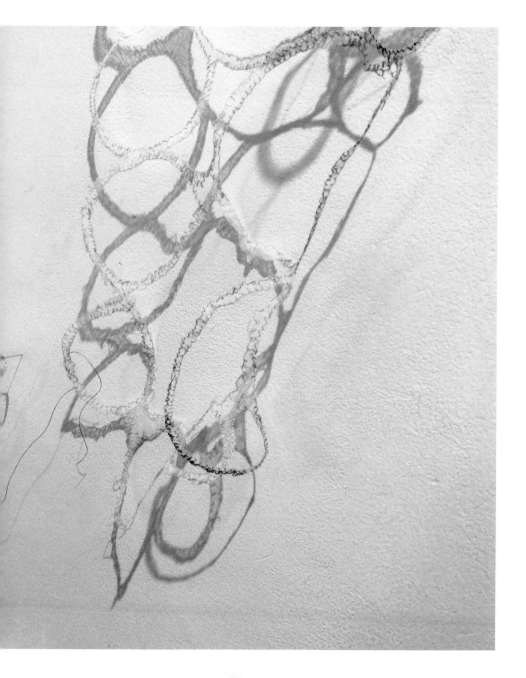

가을 여인
Autumn Woman

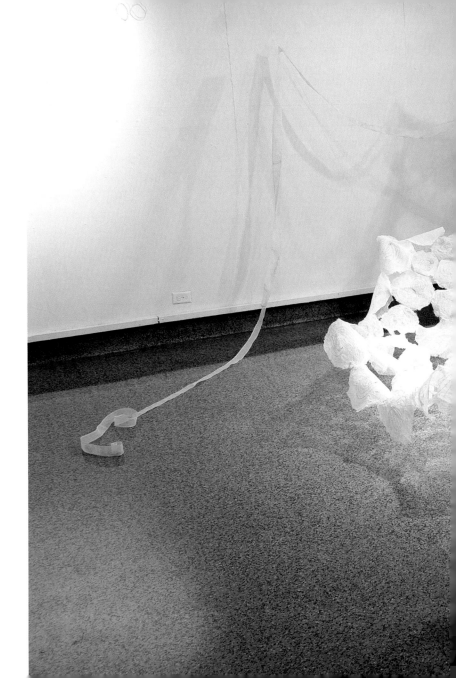

씨앗 (앞치마) Seedpods (apron), hand embroidered thread, tarlatan, earth 2008 dimension variable
Lawrence Hall Gallery, Rosemont College, PA
Photo Credit, John Wooden

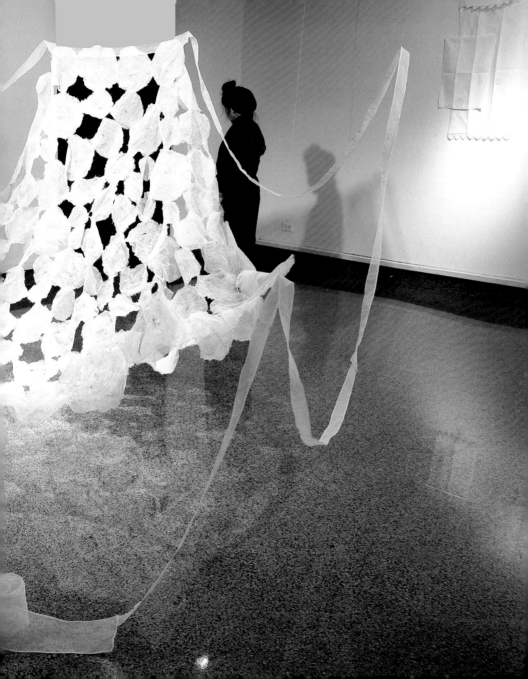

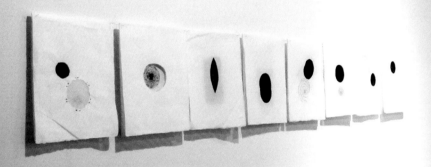

검은 달_Black Moon, 134×223cm hand embroidered thread, fabric, Korean paper 2015
트렁크 갤러리_ Trunk Gallery Seoul, Korea

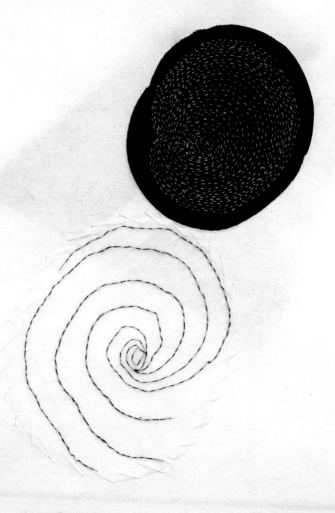

검은 달_Black Moon, hand embroidered thread. fabric, Korean paper 2015 detail

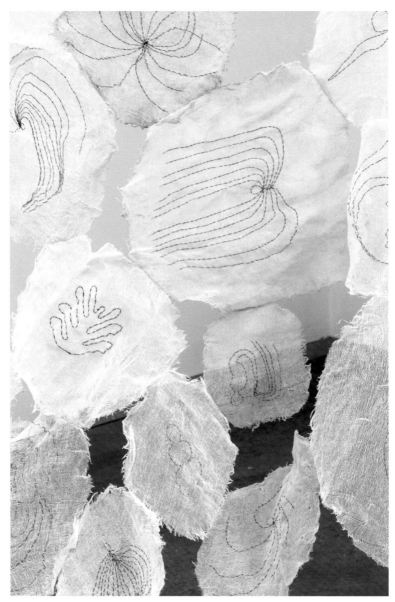

씨앗 꼬투리_Seedpods, hand embroidered thread, tarlatan, earth 2015 detail

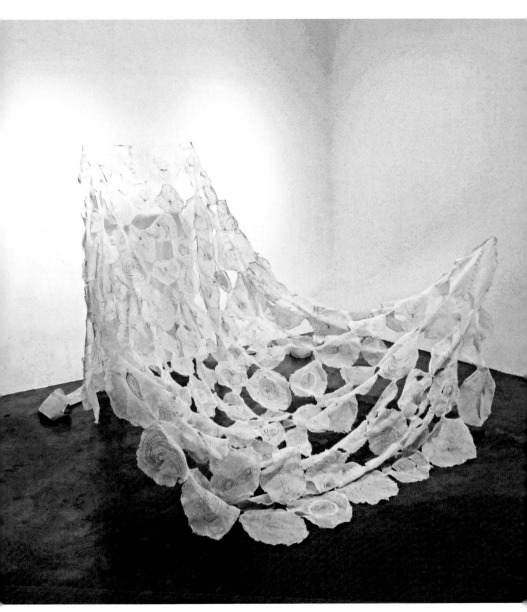

씨앗 꼬투리_ Seedpods, 240×200×157cm hand embroidered thread, tarlatan, earth 2015
트렁크 갤러리_ Trunk Gallery Seoul Korea

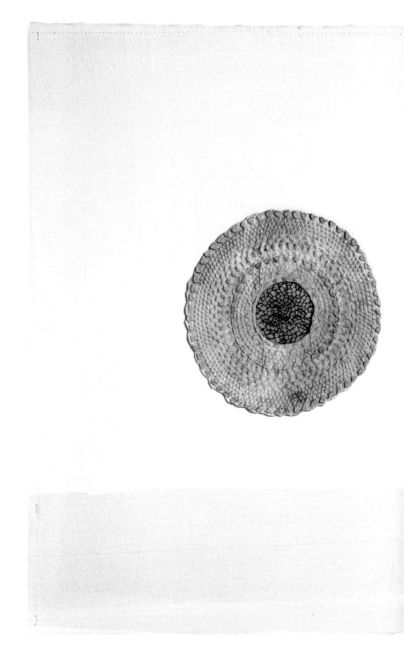

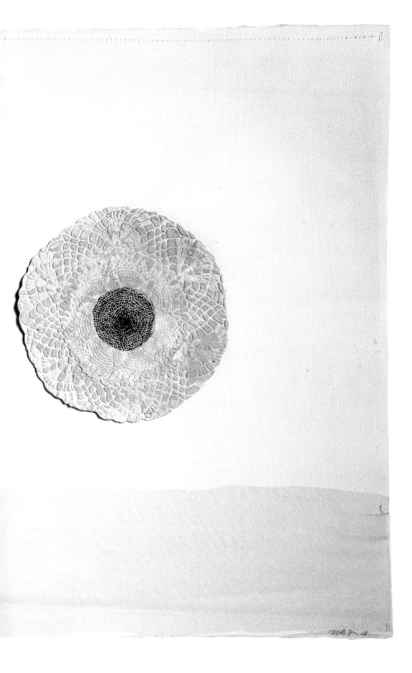

주는 꽃. Giving flower, 63×84cm hand embroidered thread, Korean pulp, mixed media 2008
Ladylike, Koscielak Gallery, IL

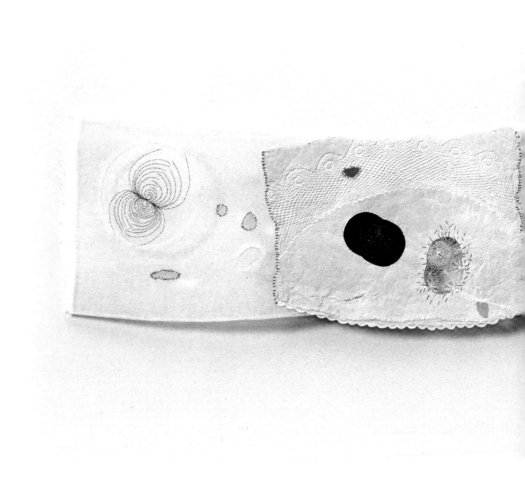

팔벼개_Arm Pillow #4, 30×112cm hand embroidered thread, Korean-pulp, mixed media 2004
Collection of The Pennsylvania Academy of the Fine Arts

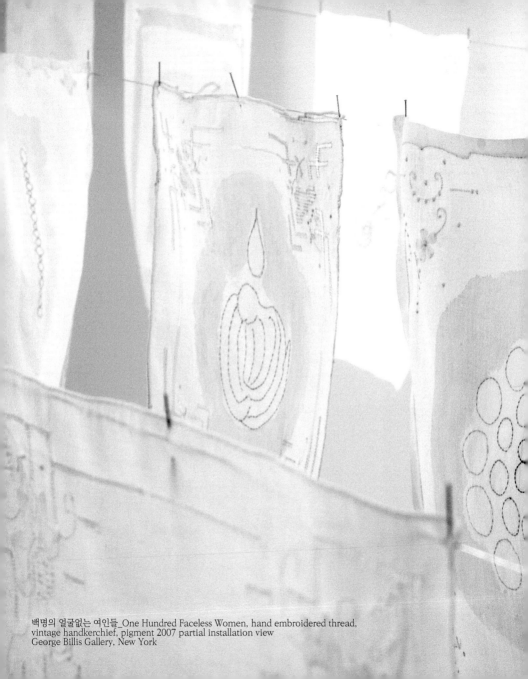

백명의 얼굴없는 여인들_One Hundred Faceless Women, hand embroidered thread,
vintage handkerchief, pigment 2007 partial installation view
George Billis Gallery, New York

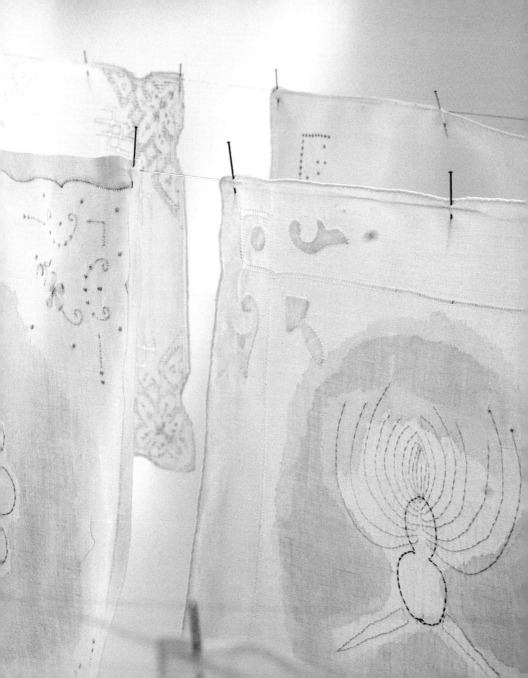

ONE HUNDRED FACELESS WOMEN

Psychoanalysts have said that grandchildren often work out the secrets of their grandparents. What has been repressed or hidden by one's ancestors ultimately clamors for expression, and takes form in strange and interesting ways.

In the art of Ke Sook Lee, the voices of her Korean grandmothers float through her installation "One Hundred Faceless Women" along with the whispers of countless anonymous females of all ages. One can almost hear the polyphonic utterances of those who fashioned the delicate, hand-made handkerchiefs Lee uses as the background for her own stitched and painted artworks. Lee has painstakingly searched for and collected these handkerchiefs over the years. They come from different continents. Many of them are decades old, and most of them sold for a pittance.

Some would see these hankies as mere discards. Lee sees them as treasures, each one unique and exquisitely hand-wrought. As a child she sewed handkerchiefs with her mother and grandmothers, and well remembers the level of craftsmanship and patience required to execute an acceptable example.

Lee's work resonates with both earlier and contemporary examples of feminist-based art. Linda Nochlin's seminal 1979 book Anonymous was a Woman: A Celebration in Words and Images of Traditional American Art and the Women Who Made It highlights the kind of handwork that women of other eras crafted, and that Lee uses as a base in this particular series. Miriam Schapiro's "Femmages," also from the 1970s, combined textiles from different countries with patterns of her own making, embracing historic aspects of female labor as well as subverting the traditional Western "high" artforms of painting and sculpture.

Lee says her minute, termite stitches are her form of drawing. On each of the small white squares of cotton, she has embroidered cryptic, semi-abstract narratives that relate to her life and that of women everywhere. A number of her central images are insect-like, with scores of appendages, versions of multi-armed Hindu goddesses. "That is because women must have many arms and legs to do all they have to do," she explains; "they must cook, clean, garden, take care of children, and work. They are struggling hard to do everything."

Other motifs are more like flower buds or seed pods. A number of these represent women, Lee says, "who had so much potential but never bloomed, or they're waiting to grow, or they're sprouting and flying."

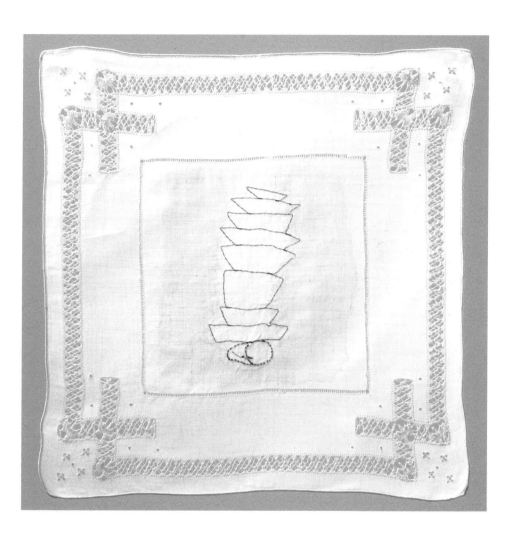

얼굴없는 여인_Faceless Woman #5, 28×28cm hand embroidered thread,
vintage handkerchief, pigment 2007

Several of the tiny works evoke mythic imagery; these represent childbirth or child-rearing, in its most painful and positive forms.

A gentle humor prevails in some pieces. In one, a peculiar organic form has a cord that disappears into an empty circle. "It's a well-educated brain that's been put in a sack," Lee states, "for women who aren't allowed to think for themselves." A bulging pole of stacked forms, Lee relates, "is like a cactus which is like a woman. A cactus shrinks when it's moved and then expands when it adjusts. They grow no matter what or where."

Lee could be speaking about her own life. She was an accomplished graphic artist and painter by the time she arrived in the United States in her early twenties, but when her children were born she stayed home for 18 years and focused on homemaking. Upon returning to art full-time, she chose to focus on textiles as the backbone of her work.

"It was a long process of searching to find the media that I am now comfortable with," Lee remembers. Ultimately she decided to focus on her personal experiences and that of other women who traditionally worked at home.

"Tiny stitches of thread started to show here and there in my work beginning in 1982 and gradually, thread became my primary media for drawing. I am attracted to fiber because of its historical elements. It bridges the gaps between generations of women. So much of our experiences as women are found in textiles. I learned embroidery and sewing from my grandmother who, like many generation of women in Korea, could not read or write. But she knew how to express her thoughts through embroidery."

For "One Hundred Facelsss Women," Lee hung 100 handkerchiefs on multiple clotheslines inside a gallery. The air circulation in the room caused the individual pieces to gently swing, recalling, she notes, "the memory of laundry day on a fine sunny day."

In these handkerchiefs, Lee says, "I like that they belonged to certain women and were used many times to touch faces. For me that is spiritual."

The background for most of the works in "One Hundred Faceless Women" is a beautiful pale blue. Lee uses that color because "so many women were kept at home day and night. I want them to be outdoors in the blue sky."

Elisabeth Kirsch, Art historian

From the One Hundred Faceless Women, Ke-Sook Lee, blurb, 100 pages, 2013

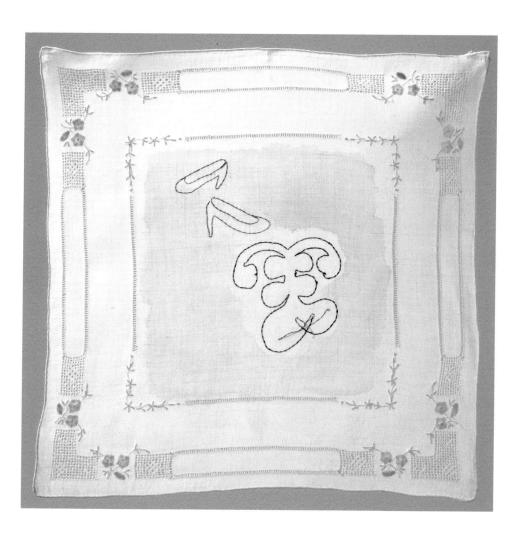

얼굴없는 여인_Faceless Woman #71, 28×28cm hand embroidered thread,
vintage handkerchief, pigment 2007

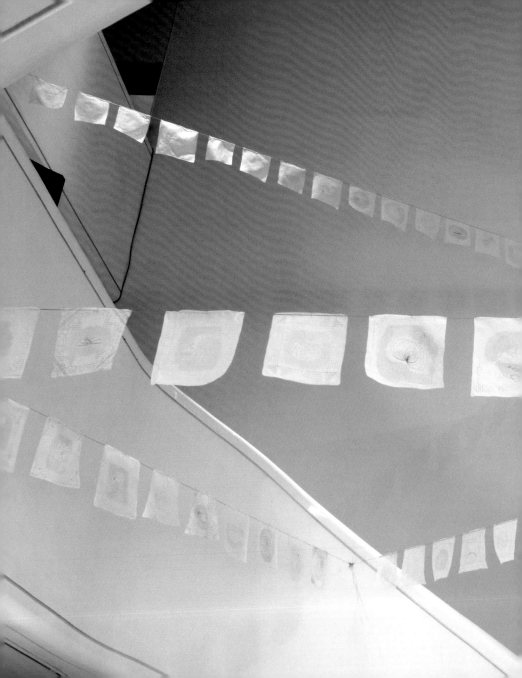

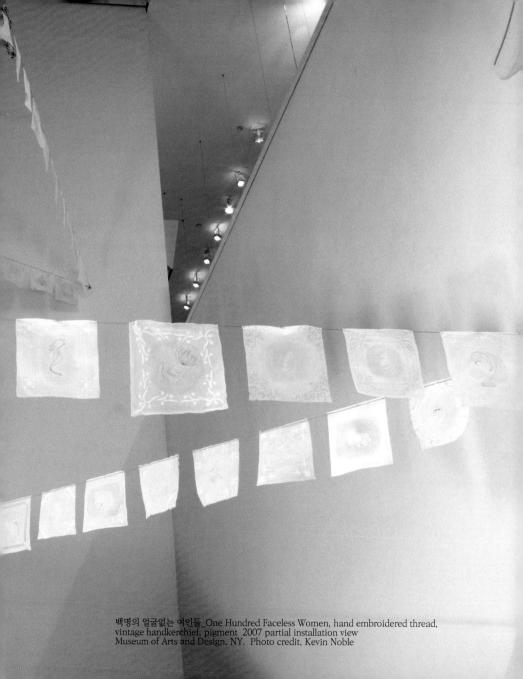

백명의 얼굴없는 여인들_One Hundred Faceless Women, hand embroidered thread, vintage handkerchief, pigment 2007 partial installation view Museum of Arts and Design, NY. Photo credit, Kevin Noble

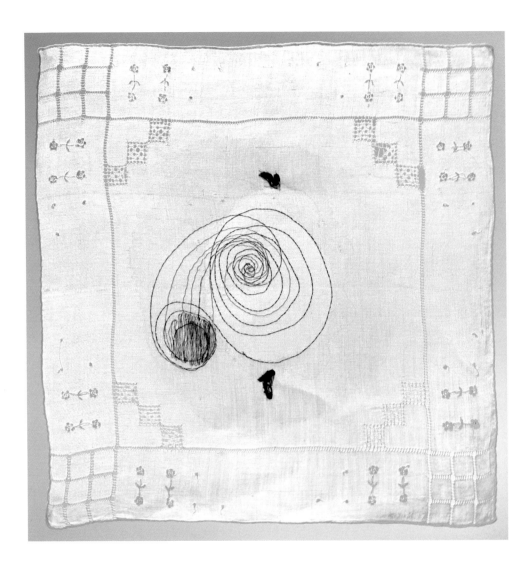

얼굴없는 여인_Faceless Woman #91, 27×27cm hand embroidered thread,
vintage handkerchief, pigment 2007

얼굴없는여인_Faceless Woman #94, 26 ×26cm hand embroidered thread,
vintage handkerchief, pigment 2007 Collection of Park Eul Bok Embroidery Museum

Ke-Sook Lee
One Hundred Faceless Women

Ke-Sook Lee drew upon personal and family memories when she created one Hundred Faceless Women. In this case her narrative memories take on a universal significance as commentary on the role of women in the domestic arena. Each handkerchief in the work has been embroidered with a motif or symbol that expresses a personal vision: "I draw personal symbols and transfigured women from my experiences of womanhood as an artist."

The relationship between needle work practices and feminism has been explored by many embroiderers over the past decades. Ke-Sook's form of mark making using thread continues that exploration by recording non-text-based imagery that speaks of the concerns, dreams and fears of past generations of women in Korea, and particularly illiterate women. "Like most of women of their generation, my grandmother and great grandmother did not know how to read or write but they did know how to express their impassioned thoughts through embroidery with patience. My work is influenced by their graceful endurance and their creativity to transform their thoughts into beautiful embroidery,"

Quote from Pricked: Extreme Embroidery, Museum of Arts and Design, NY 2007

얼굴없는 여인_Faceless Woman #98, 29×29cm hand embroidered thread,
vintage handkerchief, pigment 2007

나무여인

나는 한국 서울에서 태어나 불교 영향과 유교 가정에서 자랐고
현대화한 학교를 다녀 서양문화의 영향도 받고 배웠다.
오천년 이상의 역사를 가진 샤만 풍토적 문화도 시골에 가면 흔히 보고 자랐다
여자 샤만 무당이 큰나무밑에서 온몸을 흔들며 영혼과 통하려 춤추는 것을 보았다

한국 전쟁 동안 우리나라는 폭탄 맞어 두드려 맞고, 불타버렸다.
우리생활은 식품, 잠잘 곳 등 생활에 필요한 모든 것이 구하기 힘들어 셨다.
사람들은 나무를 잘러, 잠자는 집도 만들고 따뜻하게 집안을 덥히고, 음식도 끓었다.
전쟁이 휴전되자, 국립 식목일을 만들고 모든 국민, 학생들은 나무를 심었다.
서서히 산에 푸른 나무가 무성히 자랐고
한국땅은 울창한 푸르름으로 행복하게 살아났다.

행복한 나무를 생각하면,
나의 할머니와 어머니는 나무를 닮았다.

또 "무당" 처럼 생각하게도 한다. 두 여인들은 무당처럼 몸을 흔들며
한국전쟁 중 불구자가 된 아버지를 간호하며, 집안을 따뜻하게 덥히고,
가족들을 먹이고, 보살피고, 우리 형제들을 교육시키셨다
모든 것이 없고 부족한 형편이였지만.

나무 여인은 뿌리를 땅속으로 깊게 내리고 힘차게 땅위에 올라서서
어떤 어려운 상황에도 꺽이지 않고
양식과 쉼터로 우리를 안전하게 보호했다.

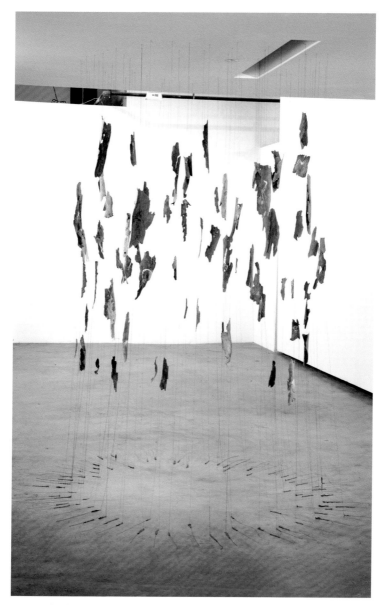

나무여인_Tree Woman, 427×304×304cm tree bark, mixed media 2009
Paragraph Gallery, Charlotte Street Foundation Urban Culture Project
Photo credit, E G Schempf

Tree Woman

I was born and educated in Seoul, Korea,
based on Confucianism and Buddhism background.
Also I attended modern school influenced by Western culture.
Often more than 5000 years old shamanistic culture
was still practiced in the countryside.
I often encounter Mudang the female shaman shaking
her body under a big tree to connect to the spirit world.
The tree was sacred and respected.

During the Korean War, our country was beaten and burnt by bombing.
Our lives became harder with, food, housing, and shortage of supplies.
People chopped down trees making shelter for cooking, and heating.
After war has been stopped
"Sig-Mok-Il" national tree planting day was born.
Students and adults participated in replacing the lost trees.
Eventually mountains are covered with green trees,
the country became happier and flourished by the green trees.

When I think about the happy tree friend
it reminded me that my grandmother and mother.
Also I thought of them as "Mudang" female Shamans.
They did shook their body hard to help my father who became disabled
during the Korean war,
kept the house warm, nurtured family and support children's education
no matter how little they had.

The tree Woman rooted deep under the ground stand strong with flexibility
not to break down no matter how the weather brought us hardship.

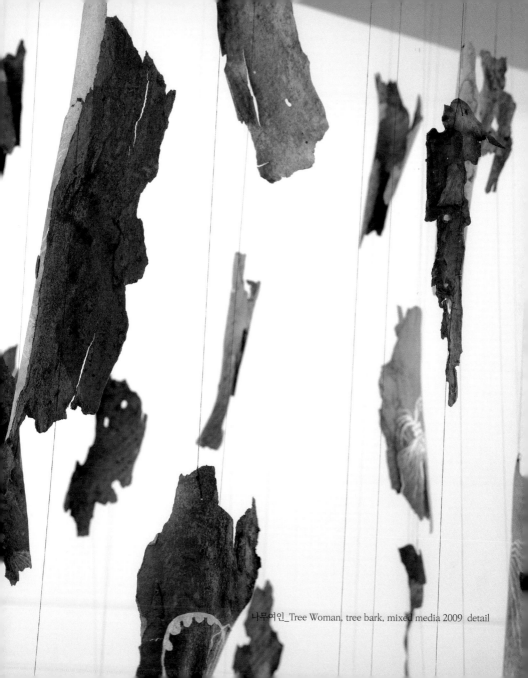

나무여인_Tree Woman, tree bark, mixed media 2009 detail

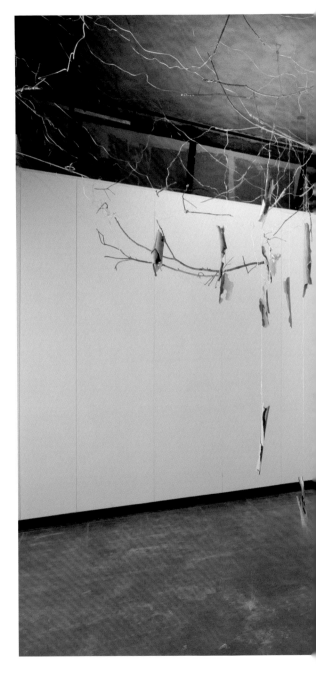

나무의 인_ Tree Woman, tree bark twigs, mixed media, 2010 dimension variable
Collaborated Grant Project at the Town Plaza, KS with dance, music and installation

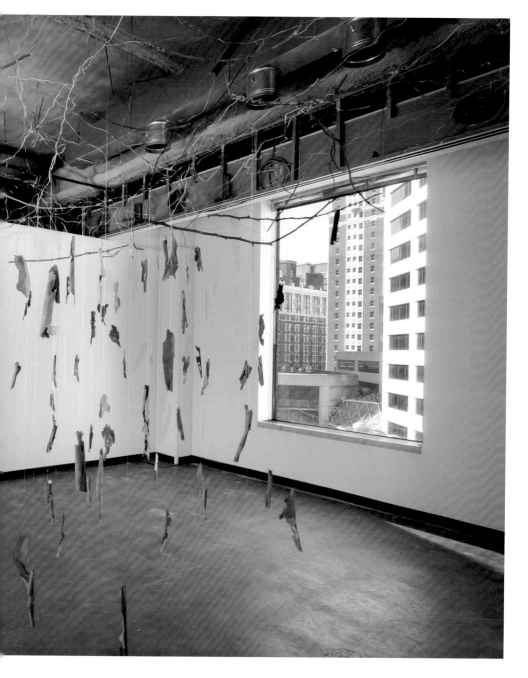

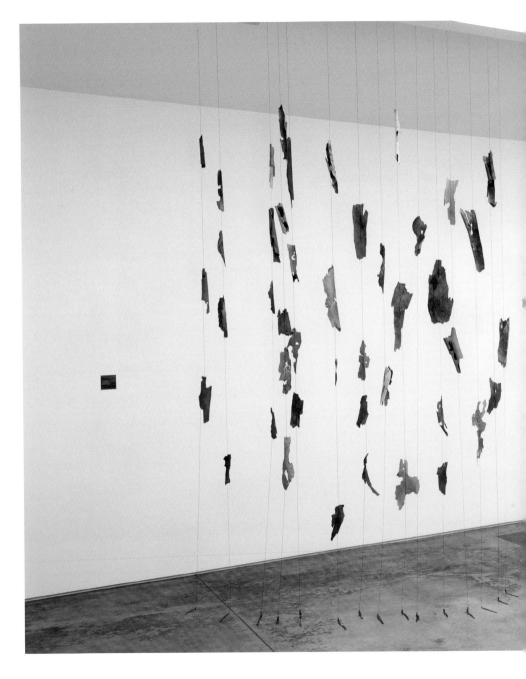

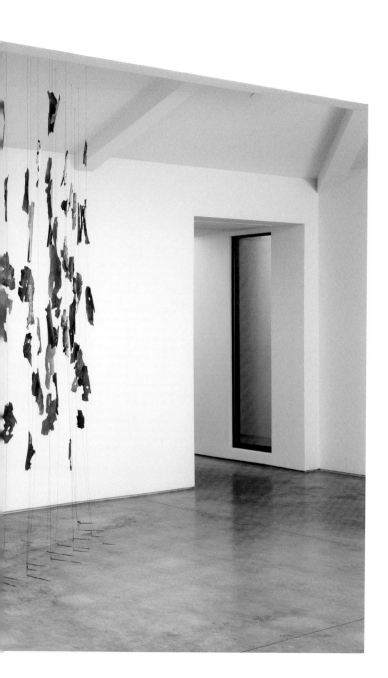

나무여인_Tree Woman tree bark, mixed media 2011 dimension variable
Sturt Haaga Gallery at Descanso Gardens Los Angles CA
Photo credit, Robert Wedemeyer

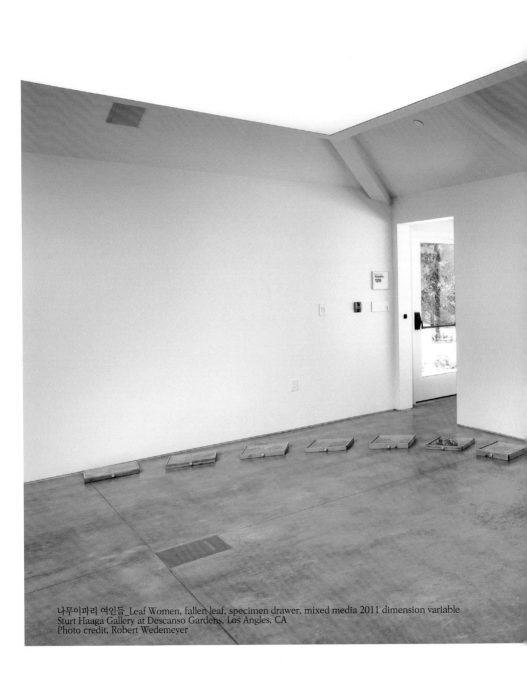

나무이파리 여인들_Leaf Women, fallen leaf, specimen drawer, mixed media 2011 dimension variable
Sturt Haaga Gallery at Descanso Gardens, Los Angles, CA
Photo credit, Robert Wedemeyer

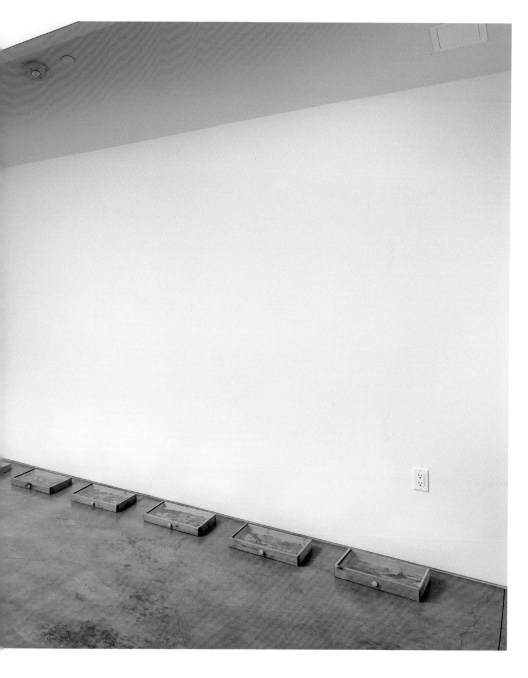

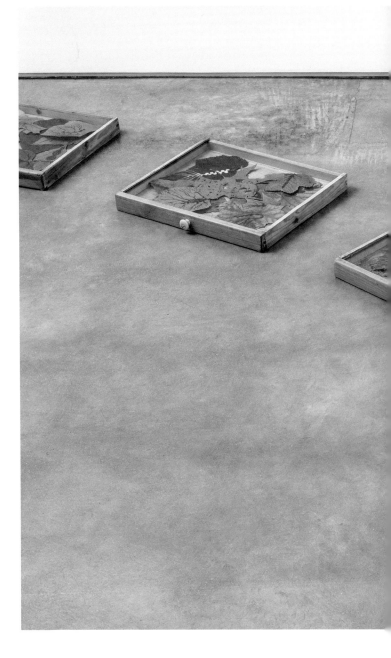

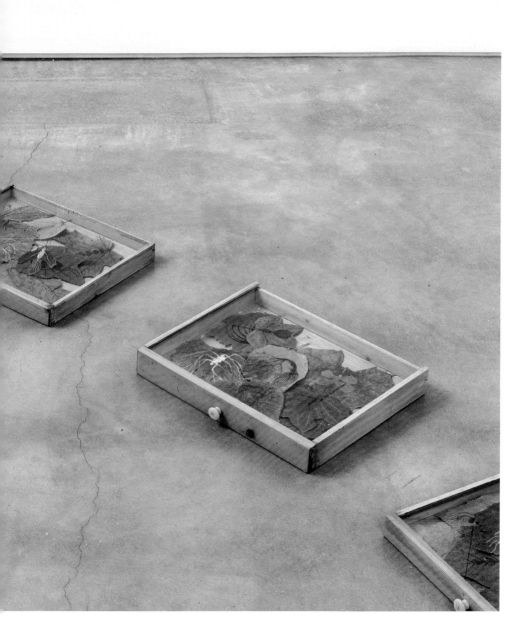

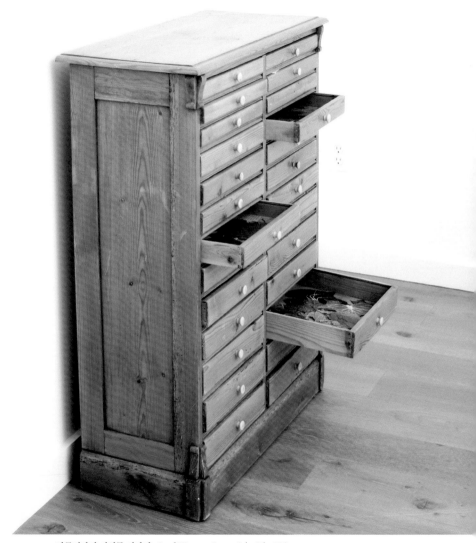

나무이파리 여인들 이야기_ Leaf Women Story 84×36×103cm
hand embroidered thread,fallen leaf, specimen cabinet, mixed media 2014

떨어진 잎사귀 여인들 이야기

한국에 가을이 오면, 떨어진 가랑잎을 주워서
책갈피에 넣고 말려서
아름다운 그림보듯 간직하고 즐기고 보았었다.
미국에서 오랜 세월 보내며 지나는 동안도
아직도 가을이 오면 가랑잎을 줍는다
예전보다 더욱 사랑스러움을 느끼며.

나무는 겨울잠을 대비해
나무잎은 필요없어져, 떨어지게 되니
수많은 떨어져 버려진 가랑잎들은
수북히 산더미처럼 쌓였다가
바람이 불면 이리저리 버석거리며
힘없이 굴러다니다가
아무 흔적도 남기지않고
소리없이 영원히 사라진다
마치 옛여인들이 소리없이 사라졌듯이.

나는 왠지 그 버려진 나무잎에
훌쩍 떠나가신 할머니 어머니들을 그려본다
곤충채집 설합장에 이파리들을 전시해 간직하고
가끔 들여다보고, 그녀들의 이야기를 들어본다
마치 채집장이 옛여인들의 이야기 도서관인듯.

Fallen Leaf Women

The Autumn in Korea, I used to collected fallen leaves from the tree,
kept them between the book pages, pressed down to dry
to look at them often like a beautiful picture.
I found myself collecting the fallen leaves
after all these years living in US
with much more affection.

Tree leaves are no longer needed
as the tree has to prepare winter sleep.
The countless fallen leaves pilled up as mount.
Then making rustling sounds by the wind,
rolling around this way and the other way
through every direction helplessly,
without leaving any significant marks
then gone forever silently.
As if our older generation of women has gone silently.

I found myself drawing our grandmothers
and mothers on the fallen leaves.
Displayed the leaves in the insect specimen drawer chest
to visit them often, and hear their stories
as if it is a library of women's story.

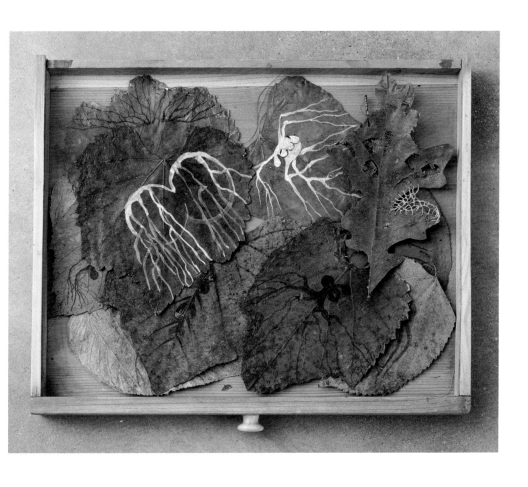

나무이파리 여인들 _ Leaf Women, 29×36×3cm fallen leaf, specimen-drawer, mixed media 2011

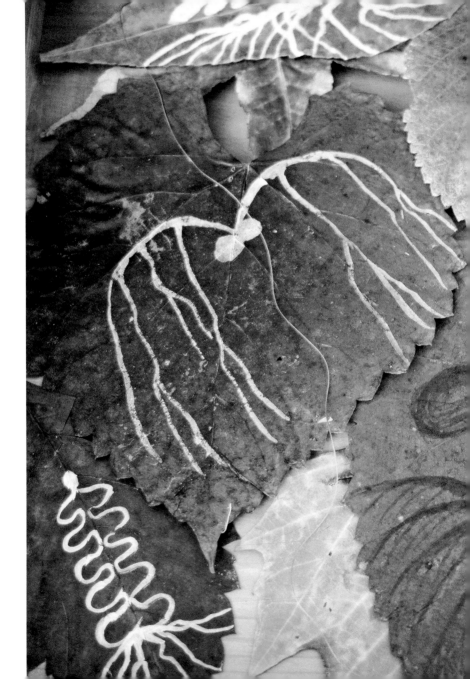

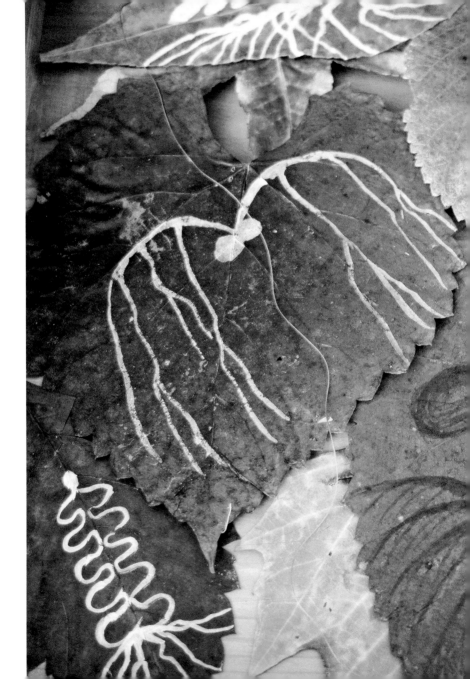

나무 이파리 여인들이야기_Leaf Women Story, hand embroidered thread, fallen leaves, mixed media 2014

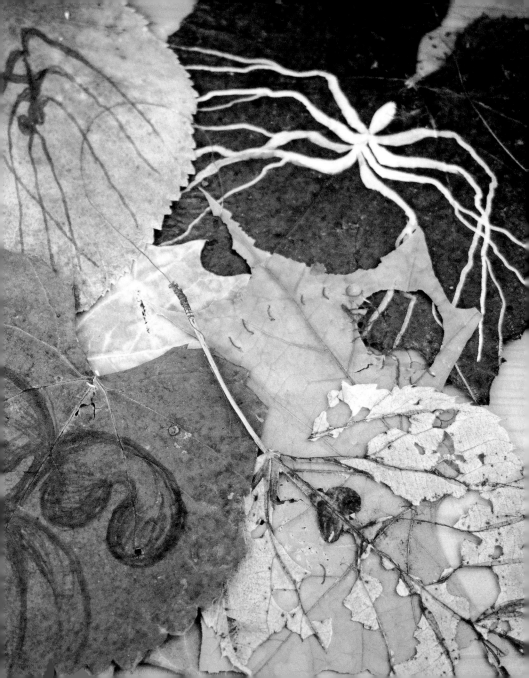

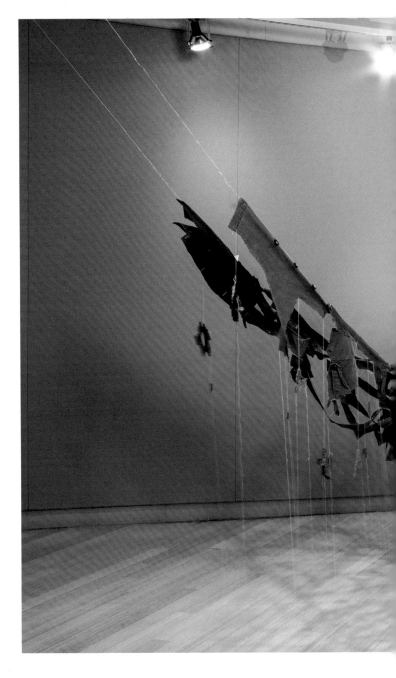

퍼런 해믹 Green Hammock, 424×182×178cm US army women's nurse uniform from Vietnam war, mixed media 2010
Carter Art Center, Kansas City Art Institute 125th Anniversary exhibition

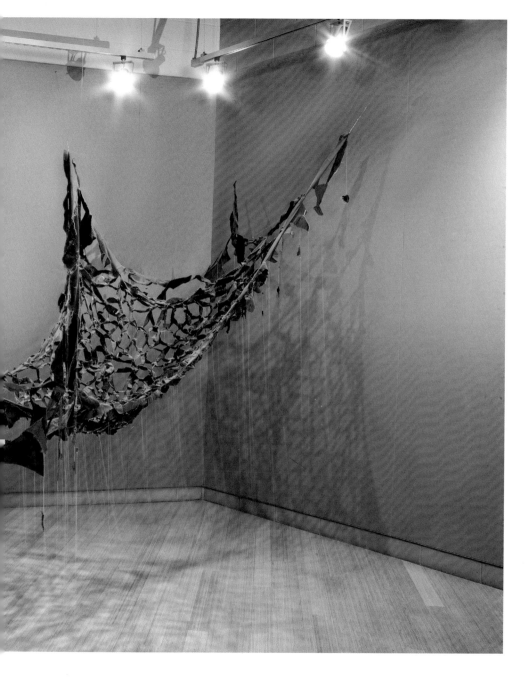

퍼런 해먹

지나간 세대가 남긴 흔적들을
뒤져 보는것은 나의 취미다
여자들이 쓰던 섬유 물건들이 각별히 흥미롭다.

군대물건 공급 상점에 들어 가보니
전쟁터에서 쓰던 물건들이 산더미 처럼 쌓여있다.
내가 본적이 있는 헬멭, 물병, 담요,
접는 침대 등... 즉시 어릴적 육이오 한국전쟁
기억이 새롭게 떠올랐다.

특히 비엣남 전쟁터에서 썼던
미국 여군인 간호복들이 눈에 띄었다.
간호복을 검토해보고
그녀들의 신분 번호표, 헐어진 구멍
타버린 옷구멍, 찢어진 옷자락
없어진 단추들을 봤을때
부상당한 군인 들을 정성껏 간호하는
여자 간호사 모습이 떠올랐다.

작품은, 바늘에 실을 꿰들고
아직도 이곳 저곳에서 전쟁 터지는걸 본다
어머니가 전쟁터에서 자식을 잃고
소리쳐 우는 소리도 들린다
바늘과 실은 급히 뛰며
전쟁의 그림자를 추적해본다.

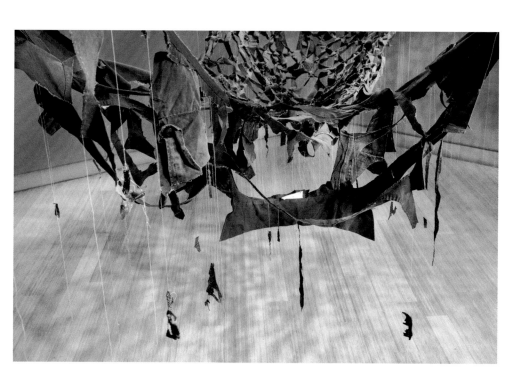

퍼런해먹_Green Hammock, US army women's nurse uniform from Vietnam war
mixed media 2010, detail, Fiber Philadelphia, Philadelphia Arts Alliance, PA

Green Hammock

Exploring trace of life from the past generation
is one of my favorite thing to do.
Specially searching women's used fiber items.

As I worked into the army supply store,
there were piles of used items during the war.
Which I am familiar with, uniforms, helmets, canteens,
blankets, holding beds, immediately my memory
of Korean War as a little girl was refreshed.

Specially US Army women's nurse uniforms
Vietnam war caught my eyes.
While examining the marks on the uniforms
their identity tags, worn holes, stains, burnt marks,
torn parts, missing buttons.
View of female nurses busy caring
wounded soldiers were flashed.

The work, holding needle and thread
facing the war which are still on here and there,
hearing the mother's scream
who lost her child in the war.
The needle and thread runs hurriedly
to hunt the shadow of the war.

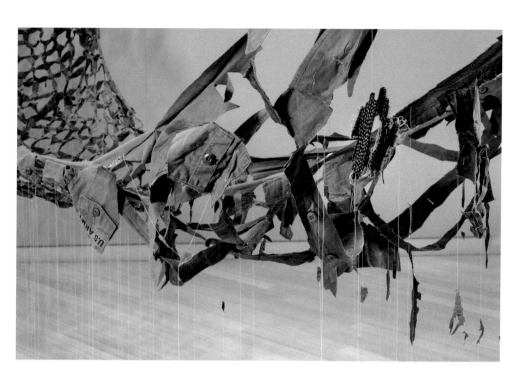

퍼런해먹_Green Hammock, US army women's nurse uniform from Vietnam war 2010 detail

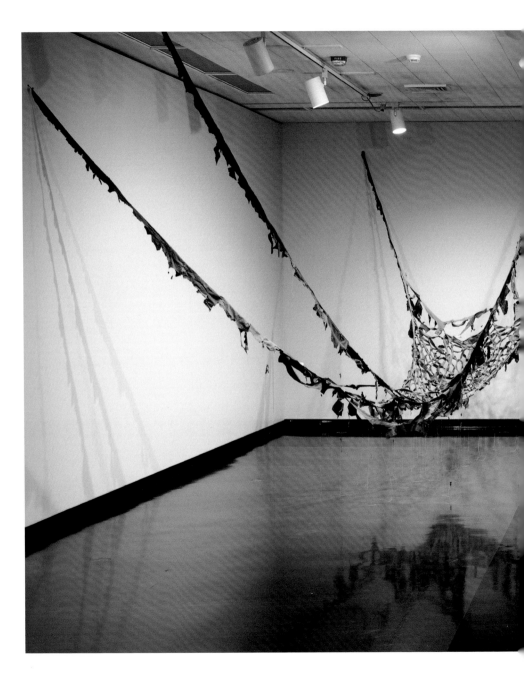

권현빈_Green Hammock, US army women's nurse uniform from Vietnam war 2010 detail
Collection of Spencer Art Museum, University of Kansas

Profile

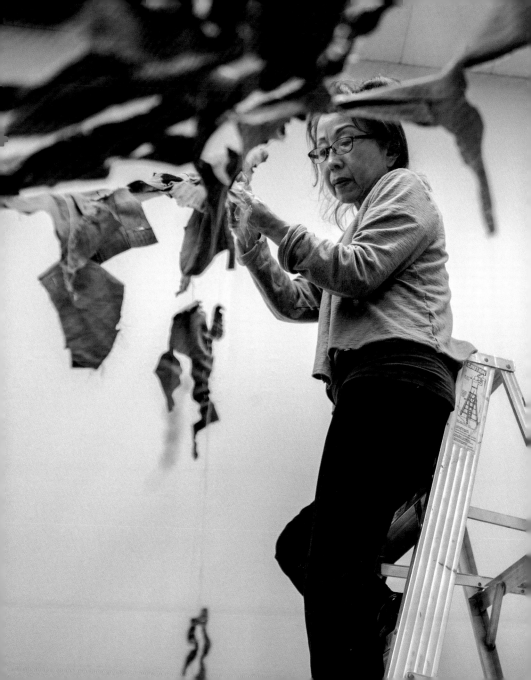

오계숙 吳桂淑

학 력
1988-90 캔사스 아트인스티튓, 멀티미디어 소묘강사
1982　　 캔사스 아트인스티튓, 회화과학사
1966-67 미조리주립대학 멀티미디어 소묘석사과정수료
1963　　 서울대학교 미술대학 응용미술과학사

개인전
2015 위험한 바누질의 속닥거림 _트렁크 갤러리, 서울
　　　새싹노래 _죠지빌리스 갤러리, 뉴욕
2012-13 꿈꾸는 씨앗 _아트링크, 서울
2011 앞으로내딧기 _죠지빌리스 갤러리, 뉴욕
2009 실의 속닥거림 _돌핀 갤러리, 캔사스
　　　창문 _죠지빌리스 갤러리, 로스안젤스
2008 오계숙: 실의 추억/ 설치 _로렌스 갤러리,
　　　로즈몬대학, 펜실바니아
2007 백명의 얼굴없는 여인들 _죠지빌리스 갤러리, 뉴욕
2005 씨앗 _죠지빌리스 갤러리, 로스안젤스
　　　수놓기 모아 모아 _죠지빌리스 갤러리, 뉴욕
2004 정원에서 나온 바느질 _슈나이더만 갤러리,
　　　필라델피아, 펜실바니아
　　　정원에서 나온 노트 _문학작가회관, 캔사스시, 미조리
2003 씨앗심기 _죠지빌리스 갤러리, 뉴욕, 미국
2002 오계숙 믹스미디아 데쌍 _갤러리 르포 오푸노,
　　　파리, 불란서
2001 정원 이야기 _돌핀 갤러리, 캔사스
2000 정원에서 기다리다 _로렌스 갤러리, 로즈몬대학,
　　　펜실바니아
　　　오계숙: 종이작품 _월스갤러리, 필라델피아, 펜실바니아
　　　정원에서 _센서스스미스 갤러리, 캔사스시, 미조리

그룹전
2016 정치의 얼굴: 참는 포용력 _홀러 크래흐트 뮤지움,
　　　마사츄셸
2015 에꼴 드 아미 레지던시 2015, 아미 뮤지움, 당진
　　　부산아트쇼, 죠지빌리스 갤러리, 뉴욕
　　　어포더블 앨해어, DDDP, 트렁크갤러리, 서울
2014 패턴 잡아서 _스펜서 뮤지움, 캔사스주립대학,
　　　로렌스, 캔사스
　　　풍경의 조각전 _박을복 자수미술관, 서울 (6인전)
　　　여기 _버클리 아트센터, 캘리포니아
2013 여섯가지시선전 _박을복 자수미술관, 서울 (6인전)
　　　여인들의 응시 : 여류화가들 그들의 세계를 만들다 _
　　　펜실바니 아카데미어브알
　　　KIAF 아트쇼, 코엑스 서울_ 아트링크 갤러리, 서울
2012 주목 해야할 여인들 2012: 섬유 계통 _
　　　미조리주립대학, 대학장 갤러리
　　　기본요소 _스탈하가 갤러리, 디스칸소숲공원,
　　　로스안젤스
　　　장소의 느낌 _필라델피아 예술협회 전시장, 펜실바니아
　　　추상·캔사스시 _너만 현대미술관, 오버랜드팍, 캔사스
　　　산프란시스코 아트쇼 _얼굴없는여인들' 가변설치,
　　　죠지빌리스 갤러리, 뉴욕 후원
2011 밀고 나가기 _돌핀 갤러리, 캔사스시, 미조리
　　　하늘과 땅사이에서 _롹허스트 대학교, 캔사스시,
　　　미조리
　　　우리들!: 설치, 음악, 춤, 콜라보레이트 퍼휘먼스
　　　_타운풀라자, 앤디워홀재단 기금, 샤롵스트릴 재단
　　　제한 넘어서 광명 _너만뮤지움, 오버랜드팍, 캔사스
　　　푸른달 _로렌스 아트센터 현관 설치, 캔사스

핑크아트쇼 서울 _ '얼굴없는여인들' 가변설치,
　쬬지빌리스 갤러리, 뉴욕
펜 이야기: 밤 여행 과 이민 _ 공중지식 인스티튤,
　뉴욕 주립대학
2010 지금은 _카터아트센터, 캔사스씨티 아트인스시튤
　개교125 주년 기념전시
2010 플랩 화일 _에취앤아불럭 미술관, 캔사스씨티
　아트인스시튤, 미조리
장소 _로렌스 아트센터, 로렌스, 캔사스
마니아미 아트쇼 _ '하늘에서 꽃피다' 가변설치,
　쬬지빌리스 갤러리, 뉴욕
2009 추적되는 기억 _한국갤러리, 한국문화원, 뉴욕_
　뉴욕 아시아현대미술주일 관련전시
행복한나무 친구들 (2) _파라그라프 갤러리,
　샤롯스트릿 재단, 캔사스. 미조리
2008 숙녀답다 _코실락갤러리, 쉬카고, 일리노이즈
바느질의 방향, 베르린 _알터 포스트, 베르린, 독일
퀫덧 런던 _ '백명의 얼굴없는 어인들,' 가변설치,
　쬬지빌리스 갤러리, 런던, 영국
2007 찌르다:심한 자수 _국제작가 초대전,
　아트디자인 뮤지움, 뉴욕
매터리얼 여자들 _리버싸이드 뮤지움, 캘리포니아
선출된 아시아컨템포러리 _산타모니카시민관,
　로스안젤스, 캘리포니아
흙 과 백: 안지얼라쳐칠, 오 계숙이, 카트린 그로테파쓰
　_크레클루 갤러리, 뉴욕 (3인전)
로스안젤스 아트쇼 _ '씨앗' 가변설치, 바카행가,
　산타모니카, 캘리포니아
어포더블 아트쇼 뉴욕 _ '얼굴없는여인들' 가변설치,

쬬지빌리스갤러리, 뉴욕
2006 제5회 국제섬유바에니얼 _쉬나이더만 갤러리,
　필라델피아, 펜실바니아
바느질의 방향, 뉴욕 _갤러리 아갈로, 부륵클린, 뉴욕
모두 다 네 잘못이다 _파라그라프 갤러리, 캔사스시,
　미조리(6인전)
어포더블 아트쇼 뉴욕 _ '씨앗,' 가변설치,
　쬬지빌리스 갤러리, 뉴욕
2005 섬유: 새로운 세계 보기 _아일랜드 국립미술관,
　아이리쉬 공화국
실의추억 _도스키 갤러리/ 계획전, 롱아이랜드, 뉴욕

수상
2010 럭퀠 그란트 _ 음악, 춤, 설치, 콜라보레잇 퍼포먼스_
　앤디워홀펀드 샤롯스트릿 화운데숀, 스펜서뮤지움
2004 펠로쉽 _캔사스아트커미션, 개인작가 그란트
2003 금메달, 새미디어 설치분야 _제4회 피렌체 국제현대
　미술전, 이태리
1999 샤롯스트릿 펀드 그란트, 개인작가 휄로쉽

Email: kesook@gmail.com

www.ke-sooklee.com

+913 706 4642

Lee, Ke-Sook

EDUCATION

1988-90 Kansas City Art Institute, Adjunct Instructor, Mixed Media Drawing
1982 Kansas City Art Institute, second B.F.A. in Painting
1966-67 University of Missouri, Post Graduate Study in Drawing
1963 Seoul National University, Republic of Korea. B.F.A. in Applied Art

Solo Exhibitions

2015 Risky Thread-Stitching Whispers _Trunk Gallery, Seoul, S.Korea
Ode to Sprouts _George Billis gallery New York, NY,
2012 Dream Seedpods _Artlink Gallery, Seoul, Korea,
2011 Stepping Forward _George Billis Gallery, New York,

2009 Thread Whisper _Dolphin Gallery, Kansas City, MO.
Window _George Billis Gallery LA, Los Angeles, CA.
2008 Ke-Sook Lee: Threads of Memory/ An Installation _Lawrence Gallery, Rosemont College, PA, in conjunction with Philadelphia International Fiber Symposium
2007 One Hundred Faceless Women _George Billis Gallery, New York, NY.
2005 Seedpods _George Billis Gallery LA, Los Angeles, CA.
Collective Stitching _George Billis Gallery, New York, NY.
2004 Stitches from her Garden _Snyderman Gallery, Philadelphia, PA.
Notes from the garden _Writers Place, Kansas City, MO.
2003 Sowing Seeds _George Billis Gallery, New York, NY.

2002 Ke-Sook Lee / Peintures et dessins technique mixte _Gallerie Lefor Openo, Paris, France,
2001 Stories from the Garden _Dolphin Gallery, Kansas City, MO.
2000 She waits in her garden _Lawrence Gallery, Rosemont College, PA.
Ke-Sook Lee: Works on paper _The Works Gallery, Philadelphia, PA.
From the Garden _Celsius Smith Gallery, Kansas City, MO.

Group Exhibitions

2016 The Faces of Politics: In/Tolerance _Fuller Craft Museum, Brockton, MA
2015 Busan Art Show _Busan Korea, Represented by George Billis Gallery New York
Affordable Art Fair_ Dongdaemoon Design Center Seoul, Korea, represented by Trunk Gallery, Seoul
2014 Holding Patterns _Spencer Museum of Art, University of Kansas, Lawrence, KS
Fragments of Surroundings _Park Eul Bok Embroidery Museum, Seoul, S. Korea
HERE _Berkeley Art Center, CA, Exhibition in two parts
2013 Six Ranges of Seeing _Park Eul Bok Embroidery Museum, Seoul, S. Korea
The Female Gaze: Women Artists making Their World _Pennsylvania Academy of the Fine Arts
KIAF Korean International Art Fair exhibition, Seoul _ Represented by the Artlink Gallery
2012 Women to Watch 2012: Focus on Fiber & Textile _University of Missouri Kansas City
Elemental _Sturt Haaga Gallery of Art at Descanso, Los Angles, CA
A Sense of Place _The Philadelphia Art Alliance, Philadelphia, PA
Abstract •Kansas City _Nerman Museum of Contemporary Art, Overland Park, KS
San Francisco Art Fair _Blossoms in the Sky, Site specific Installation, Represented by George Billis Gallery, NY
2011 Push _Dolphin Gallery, Kansas City, MO
CELESTIAL TERRESTRIALS: Between Heaven and Earth _Rockhurst University, Kansas City, MO
WE! Collaborated Performance, music, dance, installation _Town Plaza, Kansas City, MO
BEYOND BOUNDS BRILLIANT _Nerman Museum of Contemporary Art, Overland Park, KS. October
Blue Moon _ Atrium Installation, Lawrence Art Center, KS
Pink Art Fair Seoul _Faceless Women, site specific installations, Seoul, represented by George Bllis Gallery
Pen Tales On The Road: A Night of Travel & Migration _Institute for Public Knowledge at NYU, NY

2010 In the Moment _Carter Art Center, Kansas City Art
 Institute's 125th Anniversary exhibition
 2010 Flatfile _H&R Block Artspace, Kansas City Art
 Institute, Kansas City, MO
 Place _Lawrence Arts Center, Lawrence KS
 Red Dot Miami _Blossoms in the Sky, site specific
 installations
2009 Haunting Memories _Gallery Korea, Korean Cultural
 Service, NY, in conjunction with Asian
 Contemporary Art Week
 Happy Tree Friends (Part II) _Paragraph Gallery,
 Charlotte Street Foundation, MO
 BEYOND BOUNDS GLOW _Nerman Museum of
 Contemporary Art, Overland Park, KS
2008 Threading Trends Berlin _Alter Post, Berlin, Germany
 LADYLIKE _Koscielak Gallery, curated by Joanne
 Hinkel, Chicago, IL
 Reddot London _One Hundred Faceless Women, site
 specific Installation, London, England
 Women in Art: Seventy Works from the Permanent
 Collection _Ashby-Hodge Gallery of American Art, MO
 On Liberty _Dolphin Gallery, Kansas City, MO.
2007 Pricked: Extreme Embroidery_Museum of Arts and
 Design, NY
 Material Girls _Riverside Art Museum, curated by
 Andi Campognone, Riverside, CA
 A Selection of Asian Contemporary _Santa Monica
 Civic Auditorium, Los Angeles, CA
 Black n White: Angiola Churchill, Ke-Sook Lee and
 Katrin Grotepass _Crecloo Gallery, New York, NY (3
 person Show)
 Los Angeles Art Show _Seed Pods, site specific
 Installation, Barker Hangar, Santa Monica, CA
 Affordable Art Fair New York _Faceless Women, site
 specific Installation, New York, NY
 Art Now Miami _Flying Apron, site specific
 installation, FL
2006 5th International Fiber Biennial _Synderman-Works
 Gallery, Philadelphia, PA
 Threading Trends _Galeria Galau, Williamsburg
 Brooklyn, NY
 It's All Your Fault _Paragraph Gallery, Urban Culture
 Project, Charlotte Street Foundation, MO

Affordable Art Fair New York _Seed Pods, site specific
 installation, Metropolitan Pavilion, New York, NY
 Art Fair International _Seedpods and Garden, site
 specific installations, Barker Hangar, Santa Monica, CA
2005 Fiber: A New World View _National Craft Gallery of
 Ireland, Kilkenny, Irish Republic
 Threads of Memory _Dorsky Gallery /Curatorial
 Programs, Long Island City, NY

SELECTED AWARDS

2010 Rocket Grant, We collaborated performance, music,
 dance and Installation, funded by Andy Warhol
 Foundation, supported by Charlotte Street
 Foundation, Spencer Museum of Art

2004 Fellowship, Kansas Artists Commission, Individual
 Artist Grant, KS

2003 First Place in New Media and Installations,
 4th Florence Biennale International Contemporary
 Art, Italy

1999 Charlotte Street Foundation Fellow, Individual Artist
 Grant, Kansas City, MO.

Email: kesook@gmail.com

www.ke-sooklee.com

+913 706 4642